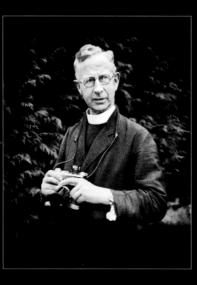

Fr Frank Browne SJ (1880-1960)

The Father Browne Yeats

E. E. O'Donnell SJ

First published in 2010 by Messenger Publications

Messenger Publications, 37 Lower Leeson Street, Dublin 2 www.messenger.ie

ISBN number 978-1-872245-75-1

The material in this publication is protected by copyright law. Except as may be permitted by law, no part of the material may be reproduced (including by storage in a retrieval system) or transmitted in any form or by any means, adapted, rented or lent without the written permission of the copyright owners.

Applications for permissions should be addressed to the publisher.

Text © 2010, E.E. O'Donnell SJ Photographs © The Father Browne SJ Collection

Father Browne prints are available from Davison & Associates, 69B Heather Road, Sandyford Industrial Estate, Dublin 18

Designed by Messenger Publications, 2010 Typeset in Garamond

Printed in Ireland by Brunswick Press Ltd

Contents

The Sad Shepherd8
The Cloak, the Boat, and the Shoes10
The Indian to His Love12
The Falling of the Leaves14
Ephemera
The Stolen Child
To an Isle in the Water
Down by the Salley Gardens
The Meditation of the Old Fisherman24
He Remembers Forgotten Beauty26
A Faery Song28
The lake Isle of Innisfree30
A Cradle Song32
The Pity of Love34
When You Are Old36
The Hosting of the Sidhe38
The Everlasting Voices
The Moods42
The Lover tells of the Rose in his Heart44
The Fish46
Into The Twilight48
The Song of Wandering Aengus50
The Song of the Old Mother52
The Lover mourns for the Loss of Love54
He Mourns for the Change56
He gives his Beloved certain Rhymes58
To his Heart, bidding it have no Fear60
The Valley of the Black Pig62
The Lover speaks to the Hearers64
The Poet pleads with the Elemental Powers

He Wishes for the Cloths of Heaven	68
The Fiddler of Dooney	70
In the Seven Woods	72
To Be Carved on a Stone at Thoor Ballylee	74
Red Hanrahan's Song about Ireland	76
O Do Not Love Too Long	
No Second Troy	
The Rose of Battle	
The Coming of Wisdom with Time	84
These are the Clouds	86
A Friend's Illness	88
All Things can Tempt Me	90
September 1913	
To a Shade	94
To a Child Dancing in the Wind	96
A Coat	
The Wild Swans at Coole10	00
An Irish Airman Forsees his Death10)2
The Fisherman10)4
The Cat and the Moon10)6
Easter 191610)8
Sailing to Byzantium11	10
The Fool by the Roadside11	
In Memory of Eva Gore-Booth and Con Markiewicz11	
Symbols	6
Spilt Milk11	18
The Choice	20
Gratitude to Unknown Instructors12	22
The Old Stone Cross12	
Under Ben Bulben 12	26

Introduction

eats needs no introduction. Father Browne needs no introduction in Ireland where he is the country's best-known photographer. Outside of Ireland he is known as the photographer of the *Titanic*, but not many people know much else about him. They do not even know that, besides his eighty-odd *Titanic* pictures, he took nearly 42,000 other photographs in four different continents.

Francis Mary Hegarty Browne, on the face of it, had little in common with William Butler Yeats. The former was born in Cork city in 1880, fifteen years after the poet. Both of them went to school in Dublin (to Belvedere College and High School respectively) but Browne gravitated towards the south of Ireland, where his Uncle Robert was Bishop of Cloyne, whilst Yeats swung between London and the north-west of Ireland, Sligo being the Yeats Country.

Browne went to the same school and University as James Joyce but afterwards their paths diverged. Joyce went into exile; Browne entered the Jesuits. He was still studying for the priesthood in 1912 when his Uncle Robert presented him with a first-class ticket for the first two legs of *Titanic's* maiden voyage: Southampton to Cherbourg and thence to Queenstown, where he was reluctant to disembark.

Browne became Father Browne when he was ordained a priest in 1915. Immediately thereafter he became a chaplain to the Irish Guards who were fighting in France and Flanders. He was injured three times and gassed once. Decorated for his bravery by

three governments, he was not demobilized until 1920 when he retired from 'The Watch on the Rhine', leaving his regiment at Cologne.

His priestly work back in Dublin, where he was Superior of the Jesuit church on Gardiner Street, was interrupted by a two-year stint in Australia, convalescing from the effects of mustard-gas. It was during this trip, one can fairly say, that he became addicted to photography. He stopped off in South Africa on the way out and returned via Sri Lanka and the Suez Canal. The Irish Ambassador in Canberra was happy to launch Father Browne's Australia in 1999.

On his return to Ireland he joined the Dublin Camera Club and the Irish Photographic Society and often spoke to the Belvedere Camera Club which he had founded in 1906.

In 1929 he was appointed to the Jesuit Retreats & Missions Staff, a position he held until his death in 1960. His photographic negatives lay moribund until 1985 when they were unearthed and transferred to safety film from dangerous nitrate material (thanks to sponsorship from Allied Irish Bank).

Now, twenty-two books of his photographs have been published, with translations into Japanese, Hungarian and French. L'Irlande du Père Browne was published in Paris to accompany the exhibition at the Pompidou Centre. Further exhibitions have been held in places like Bragança (Portugal), Hamburg (Germany), Lorient (France) and Branson (Missouri, USA). Father Browne slide-shows have

been seen in cities as far apart as Melbourne and Hiroshima, San Diego and Washington DC.

I mention all this by way of saying that it now comes as no surprise when we read *The Irish Times* assertion that Father Browne is "Ireland's leading documentary photographer". It is for this very reason that I have dared to juxtapose his work with that of Ireland's most famous poet.

Some readers will think this an unhappy combination, knowing that the men had very different philosophies and led very different lives. My belief, however, is that they had much in common from the artistic point of view. When a professional poet and a gifted photographer look at a cloud, for instance, some creative instinct snaps into life and a new artistic work is born. It little matters whether one of them, the poet in this case, spends years analyzing this creative process and the other doesn't. Their works live after them.

Obviously, some of Yeats' poems were more suitable for this book than others. It does not purport to be an anthology of Yeats' best poetry. For a variety of reasons, including length and content, some of his best poems will not be found here. Likewise, many of Father Browne's 'world class' photographs have been kept for a different book because there is not an apposite counterpart in Yeats' oeuvre. At the same time, quite a broad spectrum of poetry appears, not just the early nature poems.

Archibald MacLeish contended that "A poem should not mean, but be". I fancy that Yeats would agree that this is only *sometimes* the case in his own poetry; at other times he was making a political or theosophical statement. I have restricted my choice to

the genre envisaged by MacLeish, often to the poems that everybody knows.

My hope in juxtaposing photographs with these poems is that the readers will actually become involved in the creative process itself, along the lines of a three-line Japanese *haiku*. These classical poems have a third line that is qualitatively different from the preceding two, for example,

Old pond a frog leaps in water's sound.

In this book, whether you read the poem first and then view the image, or vice versa, a third concept is going to spring to your mind that is neither Browne's nor Yeats' but your very own.

Critics might say that Yeats would turn in his grave at Drumcliffe Churchyard (if that is where he is laid) at the very idea of being bracketed with a Jesuit. That is simply untrue. As a Belvedere boy, after all, Frank Browne attended many a Greek play – in Greek – in Yeats' High School, and his pictures of County Sligo show that he had a resonance with this part of planet Earth that was quite akin with the poet's. And even though Father Browne was in the British army while W.B. Yeats was glorifying the Easter 1916 Rising in Dublin, both men, without a shadow of a doubt, would class themselves as belonging to "the indomitable Irishry".

E. E. O'Donnell SJ

The Sad Shepherd

There was a man whom Sorrow named his Friend, And he, of his high comrade Sorrow dreaming, Went walking with slow steps along the gleaming And humming sands, where windy surges wend: And he called loudly to the stars to bend From their pale thrones and comfort him, but they Among themselves laugh on and sing alway: And then the man whom Sorrow named his friend Cried out, Dim sea, hear my most piteous story! The sea swept on and cried her old cry still, Rolling along in dreams from hill to hill. He fled the persecution of her glory And, in a far-off, gentle valley stopping, Cried all his story to the dewdrops glistening. But naught they heard, for they are always listening, The dewdrops, for the sound of their own dropping. And then the man whom Sorrow named his friend Sought once again the shore, and found a shell, And thought, I will my heavy story tell Till my own words, re-echoing, shall send Their sadness through a hollow, pearly heart; And my own tale again for me shall sing, And my own whispering words be comforting, And lo! my ancient burden may depart. Then he sang softly nigh the pearly rim; But the sad dweller by the sea-ways lone Changed all he sang to inarticulate moan Among her wildering whirls, forgetting him.

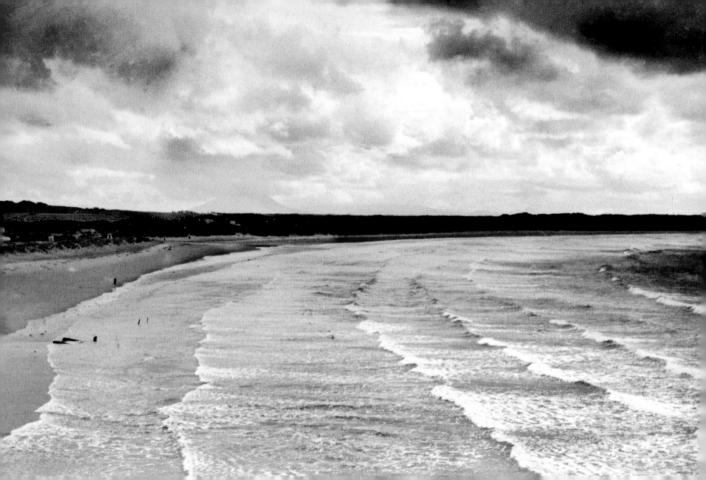

The Cloak, the Boat, and the Shoes

'What do you make so fair and bright?'

'I make the cloak of Sorrow: O lovely to see in all men's sight Shall be the cloak of Sorrow, In all men's sight.'

'What do you build with sails for flight?'

'I build a boat for Sorrow:
O swift on the seas all day and night
Saileth the rover Sorrow,
All day and night.'

'What do you weave with wool so white?'

'I weave the shoes of Sorrow: Soundless shall be the footfall light In all men's ears of Sorrow, Sudden and light.'

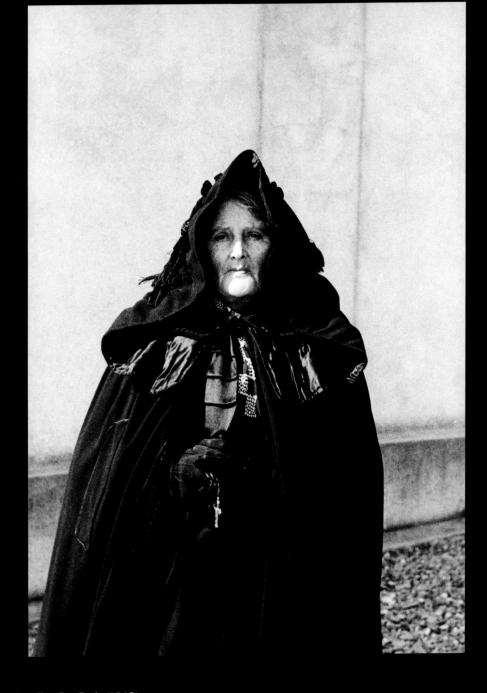

Mrs Murnane at Knockavilla, Co. Cork (1942).

The Indian to His Love

The island dreams under the dawn
And great boughs drop tranquillity;
The peahens dance on a smooth lawn,
A parrot sways upon a tree,
Raging at his own image in the enamelled sea.

Here we will moor our lonely ship
And wander ever with woven hands,
Murmuring softly lip to lip,
Along the grass, along the sands,
Murmuring how far away are the unquiet lands:

How we alone of mortals are
Hid under quiet boughs apart,
While our love grows an Indian star,
A meteor of the burning heart,
One with the tide that gleams, the wings that gleam and dart,

The heavy boughs, the burnished dove
That moans and sighs a hundred days:
How when we die our shades will rove,
When eve has hushed the feathered ways,
With vapoury footsole by the water's drowsy blaze.

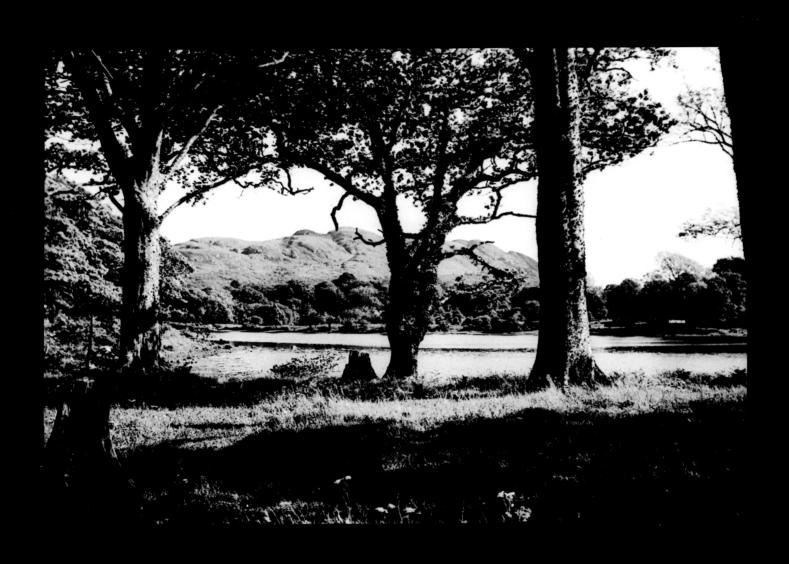

Under quiet boughs, Lissadell, Co. Sligo (1933).

The Falling of the Leaves

Autumn is over the long leaves that love us, And over the mice in the barley sheaves; Yellow the leaves of the rowan above us, And yellow the wet wild-strawberry leaves.

The hour of the waning of love has beset us, And weary and worn are our sad souls now; Let us part, ere the season of passion forget us, With a kiss and a tear on thy drooping brow.

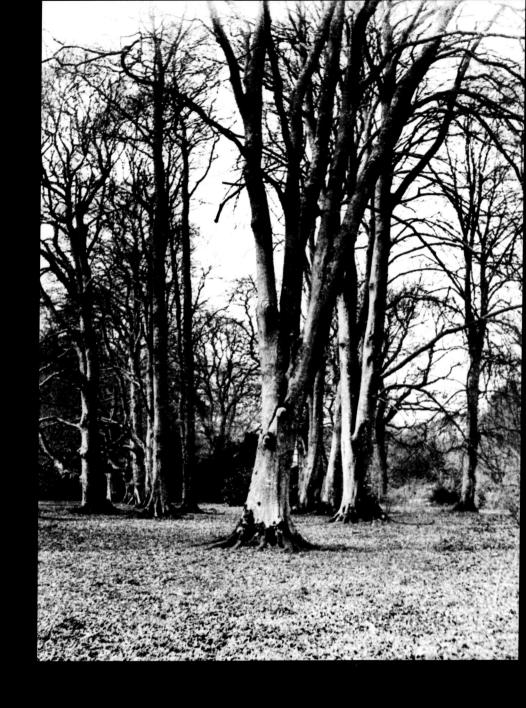

leaves, Emo, Co. Laois (1942).

Ephemera

'Your eyes that once were never weary of mine Are bowed in sorrow under pendulous lids, Because our love is waning.'

And then she:
'Although our love is waning, let us stand
By the lone border of the lake once more,
Together in that hour of gentleness
When the poor tired child, Passion, falls asleep:
How far away the stars seem, and how far
Is our first kiss, and ah, how old my heart!'
Pensive they paced along the faded leaves,
While slowly he whose hand held hers, replied:
'Passion has often worn our wandering hearts.'

The woods were round them, and the yellow leaves Fell like faint meteors in the gloom, and once A rabbit old and lame limped down the path; Autumn was over him: and now they stood On the lone border of the lake once more: Turning, he saw that she had thrust dead leaves Gathered in silence, dewy as her eyes, In bosom and hair.

'Ah, do not mourn,' he said,
'That we are tired, for other loves await us;
Hate on and love through unrepining hours.
Before us lies eternity; our souls
Are love, and a continual farewell.'

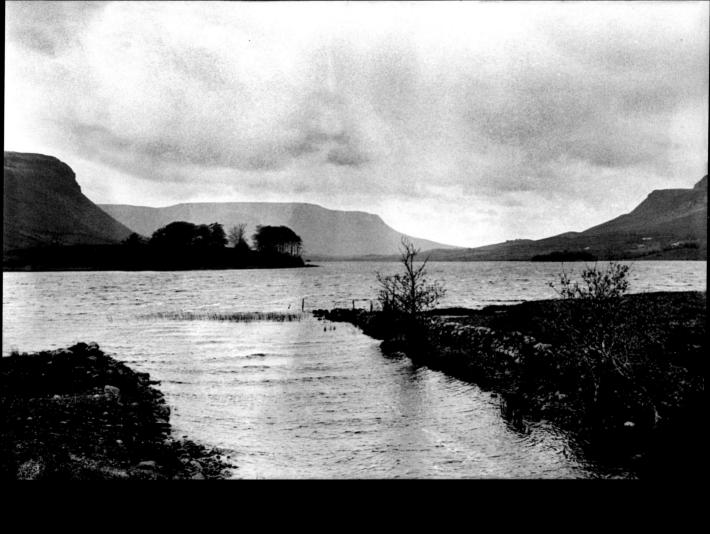

The 'lone border' of Lough Gill, Co. Sligo (1932).

The Stolen Child

Where dips the rocky highland Of Sleuth Wood in the lake, There lies a leafy island Where flapping herons wake The drowsy water-rats; There we've hid our faery vats, Full of berries And of reddest stolen cherries. Come away, O human child! To the waters and the wild With a faery, hand in hand, For the world's more full of weeping than you can understand.

Where the wave of moonlight glosses The dim grey sands with light, Far off by furthest Rosses We foot it all the night, Weaving olden dances, Mingling hands and mingling glances Till the moon has taken flight; To and fro we leap And chase the frothy bubbles, While the world is full of troubles And is anxious in its sleep. Come away, O human child! To the waters and the wild With a faery, hand in hand, For the world's more full of weeping than you can understand.

Where the wandering water gushes
From the hills above Glen-Car,
In pools among the rushes
That scarce could bathe a star,
We seek for slumbering trout
And whispering in their ears
Give them unquiet dreams;
Leaning softly out
From ferns that drop their tears
Over the young streams.
Come away, O human child!
To the waters and the wild
With a faery, hand in hand,
For the world's more full of weeping
than you can understand.

Away with us he's going,
The solemn-eyed:
He'll hear no more the lowing
Of the calves on the warm hillside
Or the kettle on the hob
Sing peace into his breast,
Or see the brown mice bob
Round and round the oatmeal-chest.
For he comes, the human child,
To the waters and the wild
With a faery, hand in hand,
From a world more full of weeping
than he can understand.

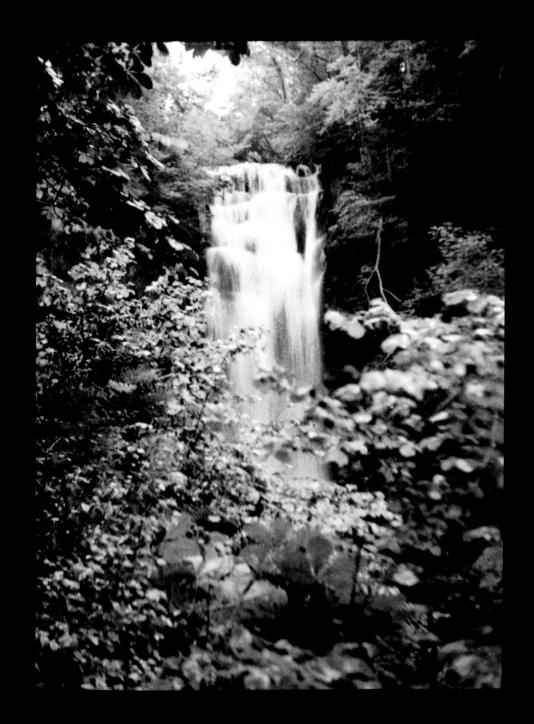

Glencar waterfall, Co. Sligo (1937).

To an Isle in the Water

Shy one, shy one, Shy one of my heart, She moves in the firelight Pensively apart.

She carries in the dishes, And lays them in a row. To an isle in the water With her would I go.

She carries in the candles, And lights the curtained room, Shy in the doorway And shy in the gloom;

And shy as a rabbit, Helpful and shy. To an isle in the water With her would I fly.

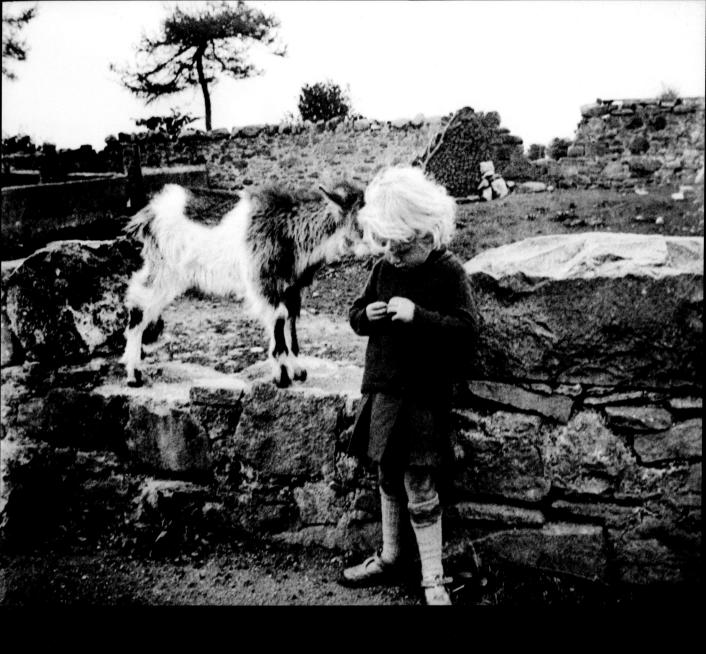

Shyness interrupted, Tubbercurry, Co. Sligo (1933).

Down by the Salley Gardens

Down by the salley gardens my love and I did meet; She passed the salley gardens with little snow-white feet. She bid me take love easy, as the leaves grow on the tree; But I, being young and foolish, with her would not agree.

In a field by the river my love and I did stand, And on my leaning shoulder she laid her snow-white hand. She bid me take life easy, as the grass grows on the weirs; But I was young and foolish, and now am full of tears.

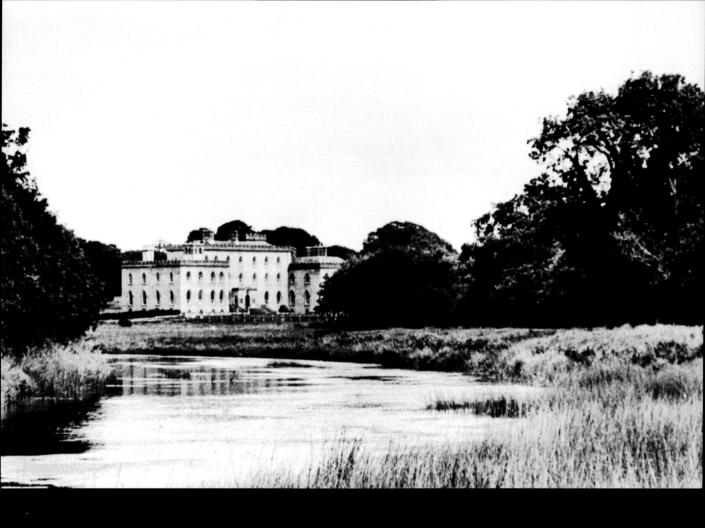

The gardens at Moore Park, Co. Kildare, where Count John McCormack sang 'Down By The Salley Gardens' for the Hollywood film 'Song Of My Heart' in 1929.

The Meditation of the Old Fisherman

You waves, though you dance by my feet like children at play, Though you glow and you glance, though you purr and you dart; In the Junes that were warmer than these are, the waves were more gay, When I was a boy with never a crack in my heart.

The herring are not in the tides as they were of old; My sorrow! for many a creak gave the creel in the cart That carried the take to Sligo town to be sold, When I was a boy with never a crack in my heart.

And ah, you proud maiden, you are not so fair when his oar Is heard on the water, as they were, the proud and apart, Who paced in the eve by the nets on the pebbly shore, When I was a boy with never a crack in my heart.

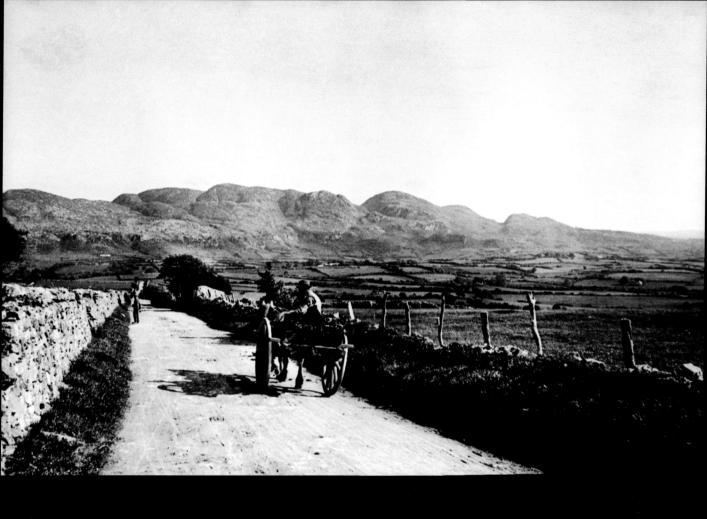

Creaky cart near Tubbernalt, Co. Sligo (1933).

He Remembers Forgotten Beauty

When my arms wrap you round I press My heart upon the loveliness That has long faded from the world; The jewelled crowns that kings have hurled In shadowy pools, when armies fled; The love-tales wrought with silken thread By dreaming ladies upon cloth That has made fat the murderous moth; The roses that of old time were Woven by ladies in their hair, The dew-cold lilies ladies bore Through many a sacred corridor Where such grey clouds of incense rose That only God's eyes did not close: For that pale breast and lingering hand Come from a more dream-heavy land, A more dream-heavy hour than this; And when you sigh from kiss to kiss I hear white Beauty sighing, too, For hours when all must fade like dew, But flame on flame, and deep on deep, Throne over throne where in half sleep, Their swords upon their iron knees, Brood her high lonely mysteries.

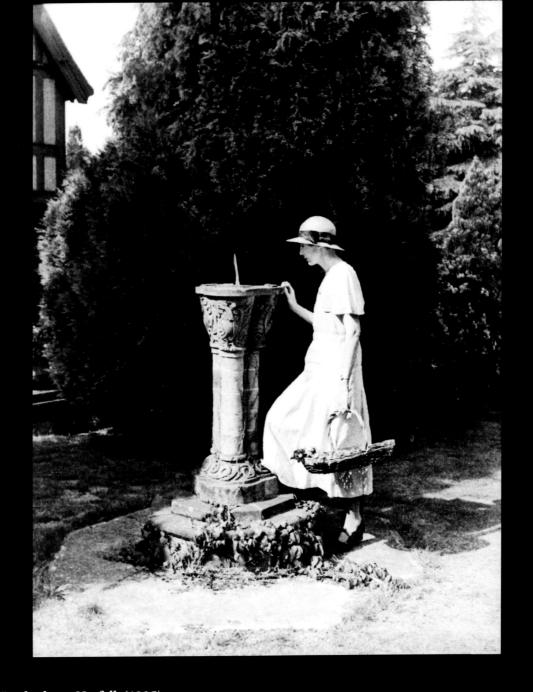

Mrs Taylor at Heatherbrae, Norfolk (1935).

A Faery Song

Sung by the people of Faery over Diarmuid and Grania, in their bridal sleep under a Cromlech.

We who are old, old and gay, O so old! Thousands of years, thousands of years, If all were told:

Give to these children, new from the world, Silence and love; And the long dew-dropping hours of the night, And the stars above:

Give to these children, new from the world, Rest far from men.
Is anything better, anything better?
Tell us it then:

Us who are old, old and gay, O so old! Thousands of years, thousands of years, If all were told.

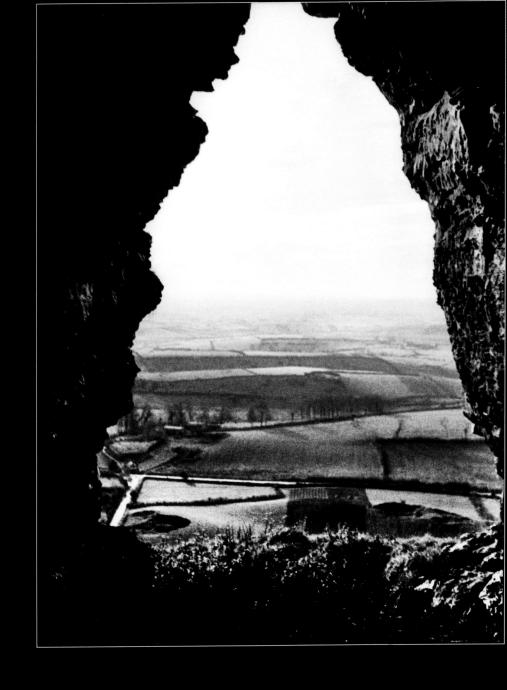

'Rest far from men' near Ballymote, Co. Sligo (1935).

The Lake Isle of Innisfree

I will arise and go now, and go to Innisfree, And a small cabin build there, of clay and wattles made: Nine bean-rows will I have there, a hive for the honey-bee, And live alone in the bee-loud glade.

And I shall have some peace there, for peace comes dropping slow, Dropping from the veils of the morning to where the cricket sings; There midnight's all a glimmer, and noon a purple glow, And evening full of the linnet's wings.

I will arise and go now, for always night and day I hear lake water lapping with low sounds by the shore; While I stand on the roadway, or on the pavements grey, I hear it in the deep heart's core.

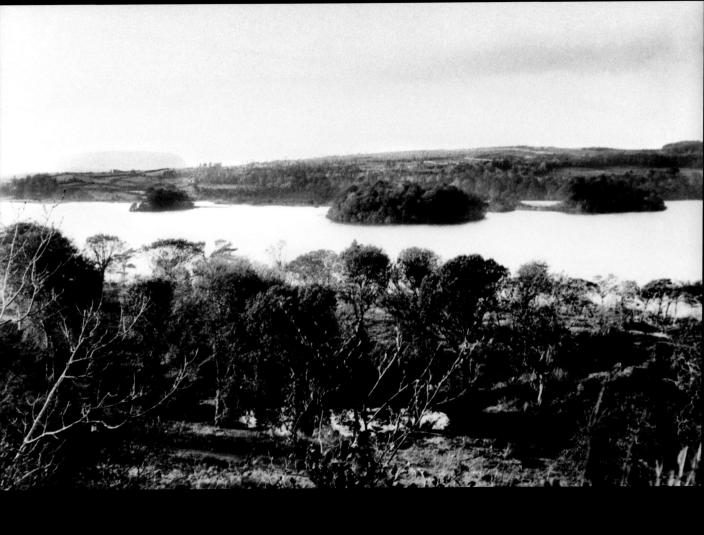

Innisfree, Lough Gill, Co. Sligo (1928).

A Cradle Song

The angels are stooping Above your bed; They weary of trooping With the whimpering dead.

God's laughing in Heaven To see you so good; The Sailing Seven Are gay with His mood.

I sigh that kiss you, For I must own That I shall miss you When you have grown.

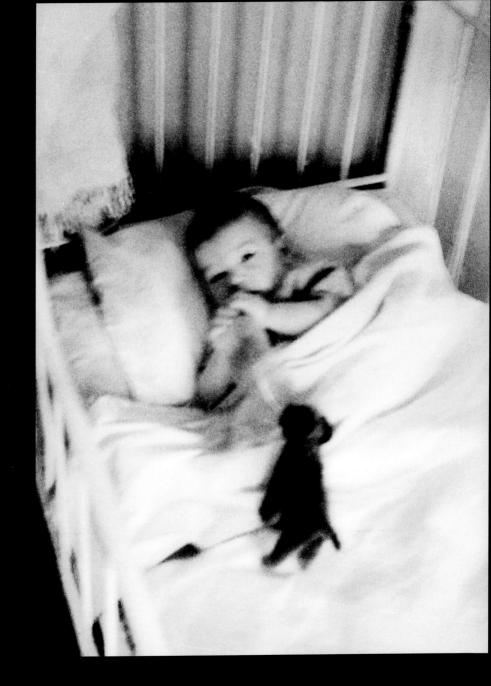

Mother & Child Scheme' booklet published by the Irish Department of Health (1950).

The Pity of Love

A pity beyond all telling
Is hid in the heart of love:
The folk who are buying and selling,
The clouds on their journey above,
The cold wet winds ever blowing,
And the shadowy hazel grove
Where mouse-grey waters are flowing,
Threaten the head that I love.

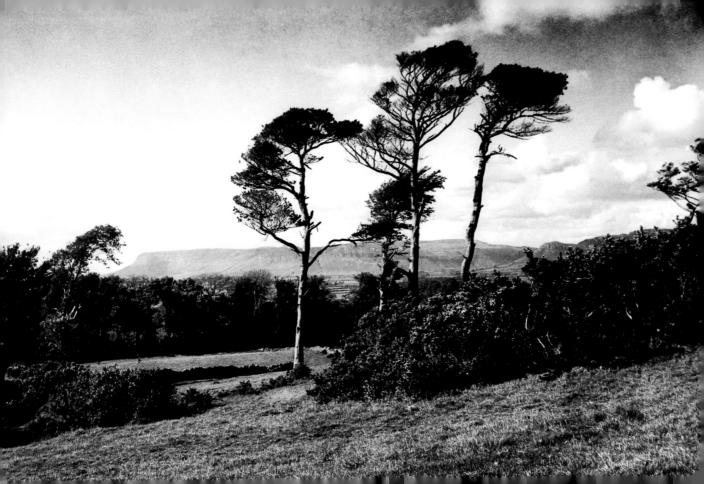

When You Are Old

When you are old and grey and full of sleep, And nodding by the fire, take down this book, And slowly read, and dream of the soft look Your eyes had once, and of their shadows deep;

How many loved your moments of glad grace, And loved your beauty with love false or true, But one man loved the pilgrim Soul in you, And loved the sorrows of your changing face;

And bending down beside the glowing bars, Murmur, a little sadly, how Love fled And paced upon the mountains overhead And hid his face amid a crowd of stars.

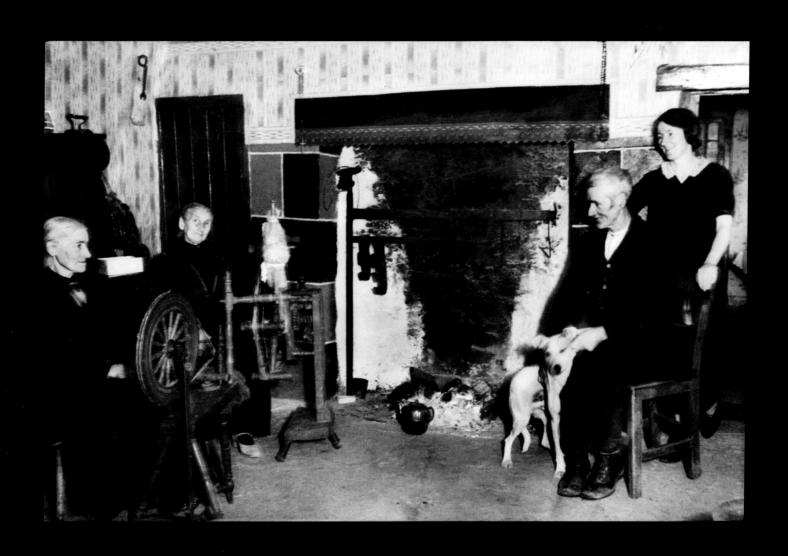

By the fireside, Drumshanbo, Co. Leitrim (1933).

The Hosting of the Sidhe

The host is riding from Knocknarea And over the grave of Clooth-na-Bare; Caoilte tossing his burning hair, And Niamh calling Away, come away: Empty your heart of its mortal dream. The winds awaken, the leaves whirl round, Our cheeks are pale, our hair is unbound, Our breasts are heaving, our eyes are agleam, Our arms are waving, our lips are apart; And if any gaze on our rushing band, We come between him and the deed of his hand, We come between him and the hope of his heart. The host is rushing 'twixt night and day, And where is there hope or deed as fair? Caoilte tossing his burning hair, And Niamh calling Away, come away.

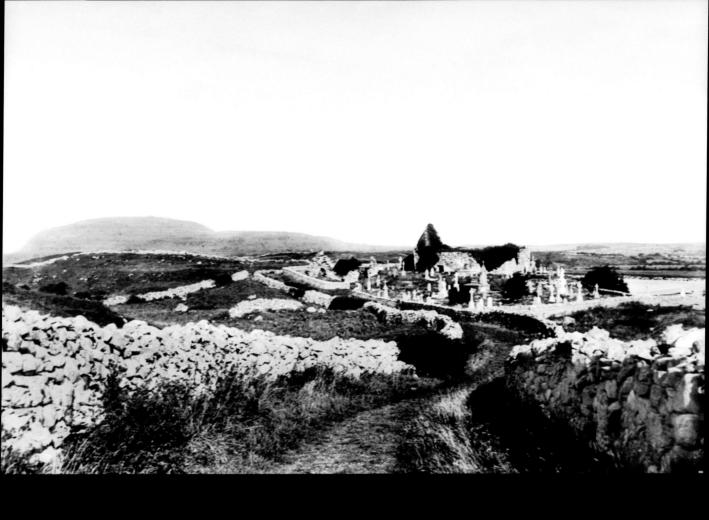

Knocknarea Mountain, with the ruins of Ballysadare Abbey in the foreground, Co. Sligo (1929).

The Everlasting Voices

O sweet everlasting Voices, be still; Go to the guards of the heavenly fold And bid them wander obeying your will, Flame under flame, till Time be no more; Have you not heard that our hearts are old, That you call in birds, in wind on the hill, In shaken boughs, in tide on the shore? O sweet everlasting Voices, be still.

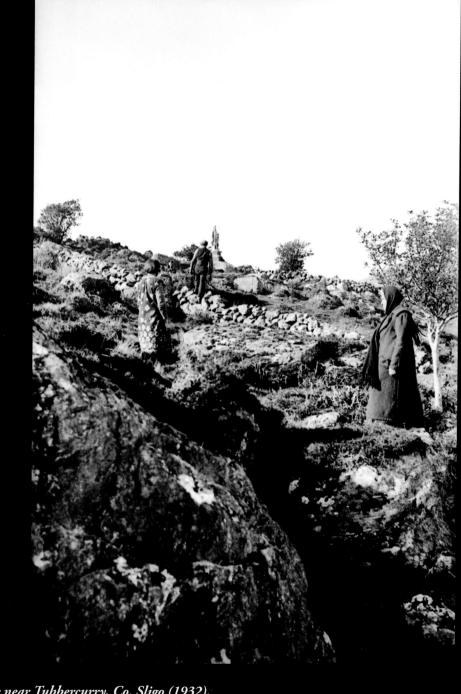

Pilgrims on hillside near Tubbercurry, Co. Sligo (1932).

The Moods

Time drops in decay, Like a candle burnt out, And the mountains and woods Have their day, have their day; What one in the rout Of the fire-born moods Has fallen away?

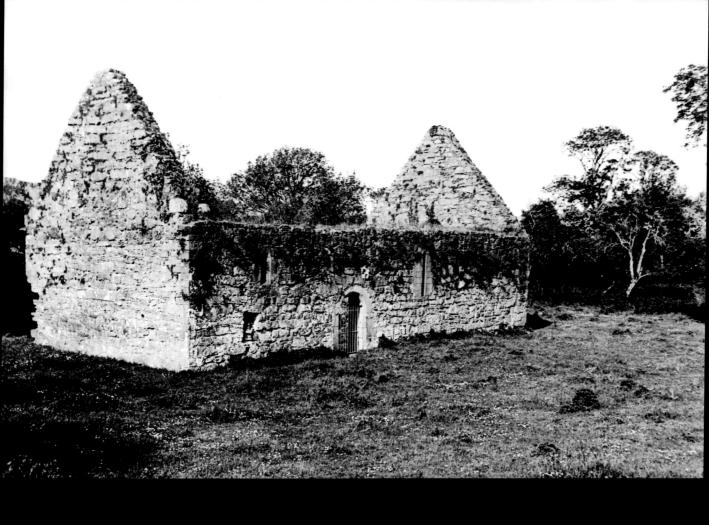

Church in ruins on Church Island, Lough Gill, Co. Sligo (1933).

The Lover tells of the Rose in his Heart

All things uncomely and broken, all things worn out and old,
The cry of a child by the roadway, the creak of a lumbering cart,
The heavy steps of the ploughman, splashing the wintry mould,
Are wronging your image that blossoms a rose in the deeps of my heart.

The wrong of unshapely things is a wrong too great to be told; I hunger to build them anew and sit on a green knoll apart, With the earth and the sky and the water, re-made, like a casket of gold For my dreams of your image that blossoms a rose in the deeps of my heart.

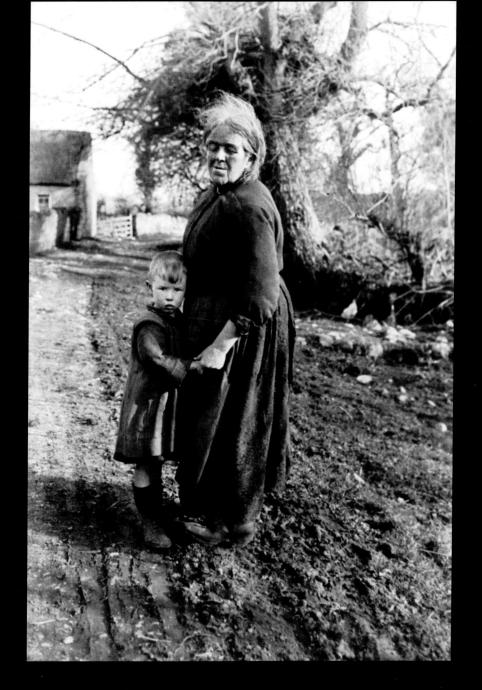

'A Lost City of the Bog', Oughter, Co. Offaly (1929).

The Fish

Although you hide in the ebb and flow Of the pale tide when the moon has set, The people of coming days will know About the casting out of my net,

And how you have leaped times out of mind Over the little silver cords,
And think that you were hard and unkind,
And blame you with many bitter words.

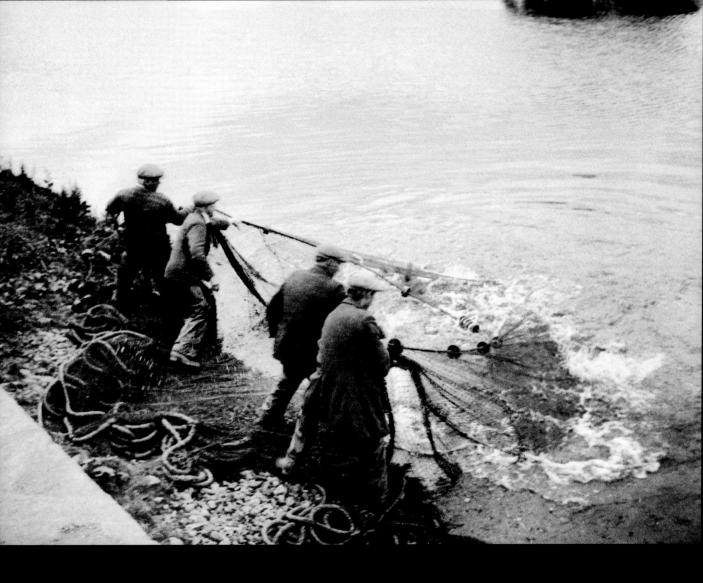

Salmon-fishing on the River Moy, Co. Mayo (1932).

Into the Twilight

Out-worn heart, in a time out-worn, Come clear of the nets of wrong and right; Laugh, heart, again in the grey twilight, Sigh, heart, again in the dew of the morn.

Your mother Eire is aways young, Dew ever shining and twilight grey; Though hope fall from you and love decay, Burning in fires of a slanderous tongue.

Come, heart, where hill is heaped upon hill: For there the mystical brotherhood Of sun and moon and hollow and wood And river and stream work out their will;

And God stands winding His lonely horn, And time and the world are ever in flight; And love is less kind than the grey twilight, And hope is less dear than the dew of the morn.

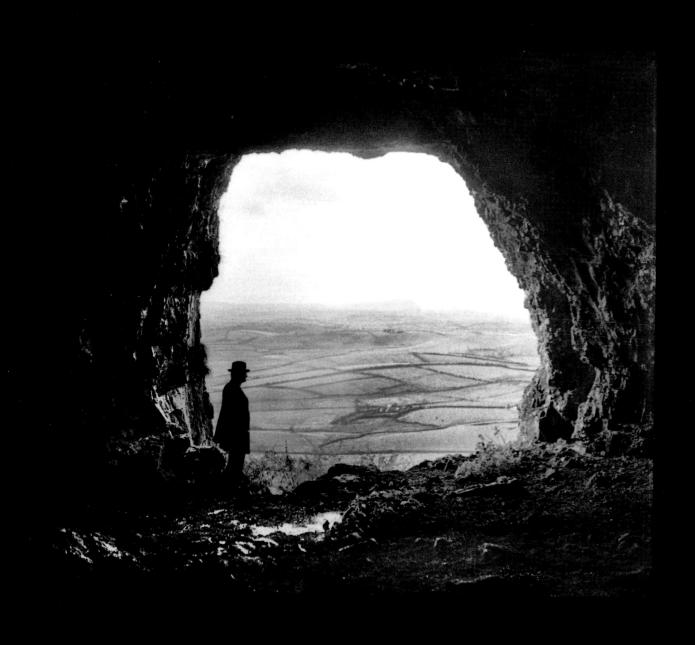

Silhouette at Kesh cave, Co. Sligo (1934).

The Song of Wandering Aengus

I went out to the hazel wood,
Because a fire was in my head,
And cut and peeled a hazel wand,
And hooked a berry to a thread;
And when white moths were on the wing,
And moth-like stars were flickering out,
I dropped the berry in a stream
And caught a little silver trout.

When I had laid it on the floor
I went to blow the fire aflame,
But something rustled on the floor,
And some one called me by my name:
It had become a glimmering girl
With apple blossom in her hair
Who called me by my name and ran
And faded through the brightening air.

Though I am old with wandering
Through hollow lands and hilly lands,
I will find out where she has gone,
And kiss her lips and take her hands;
And walk among long dappled grass,
And pluck till time and times are done
The silver apples of the moon,
The golden apples of the sun.

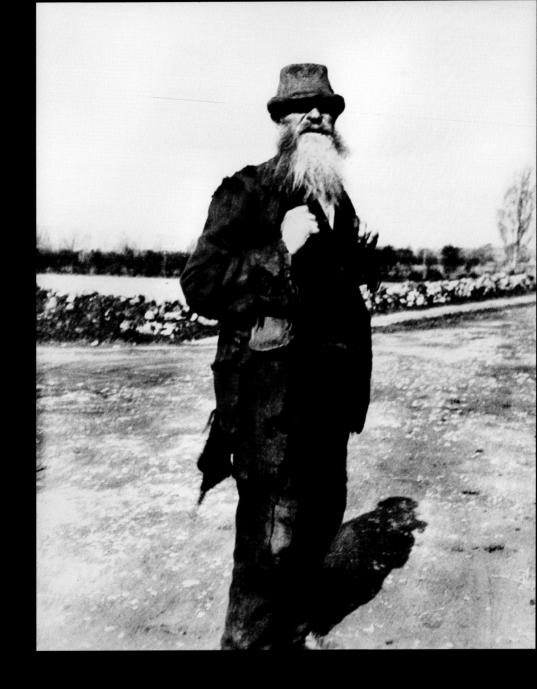

The 'Shanachie', a traditional Irish story-teller, at Carrigogunnell, Co. Limerick (1925).

The Song of the Old Mother

I rise in the dawn, and I kneel and blow
Till the seed of the fire flicker and glow;
And then I must scrub and bake and sweep
Till stars are beginning to blink and peep;
And the young lie long and dream in their bed
Of the matching of ribbons for bosom and head,
And their day goes over in idleness,
And they sigh if the wind but lift a tress:
While I must work because I am old,
And the seed of the fire gets feeble and cold.

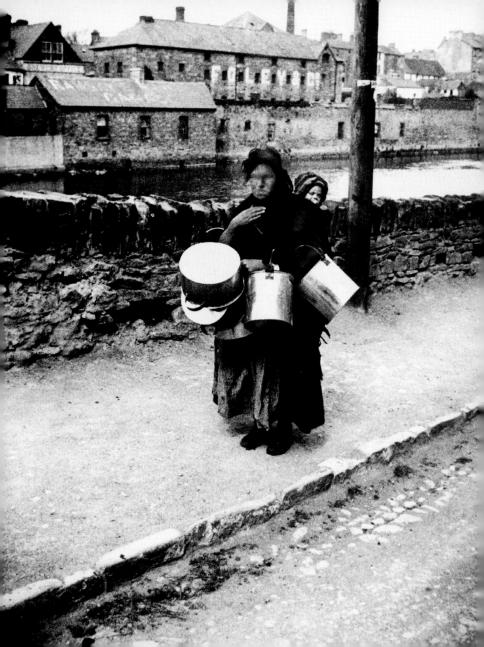

ing & ing

The Lover mourns for the Loss of Love

Pale brows, still hands and dim hair, I had a beautiful friend
And dreamed that the old despair
Would end in love in the end:
She looked in my heart one day
And saw your image was there;
She has gone weeping away.

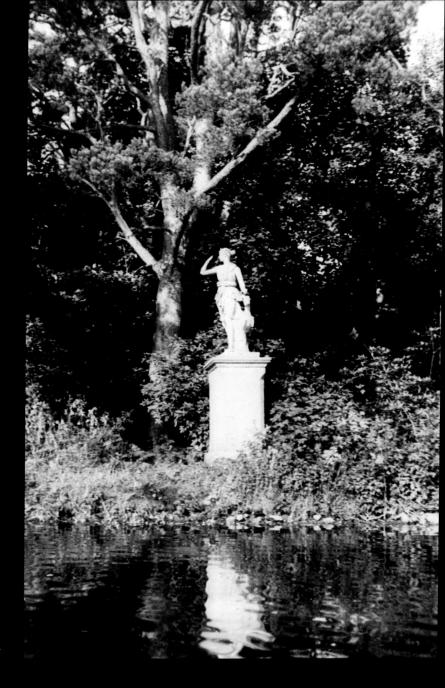

Diana, the Huntress, Emo, Co. Laois (1932).

He mourns for the Change that has come upon him and his Beloved, and longs for the End of the World

Do you not hear me calling, white deer with no horns? I have been changed to a hound with one red ear; I have been in the Path of Stones and the Wood of Thorns, For somebody hid hatred and hope and desire and fear Under my feet that they follow you night and day. A man with a hazel wand came without sound; He changed me suddenly; I was looking another way; And now my calling is but the calling of a hound; And Time and Birth and Change are hurrying by. I would that the Boar without bristles had come from the West And had rooted the sun and moon and stars out of the sky And lay in the darkness, grunting, and turning to his rest.

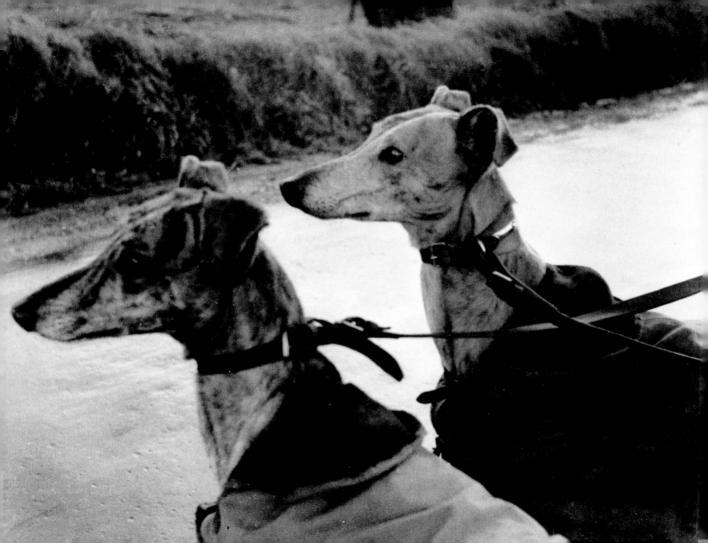

He gives his Beloved certain Rhymes

Fasten your hair with a golden pin, And bind up every wandering tress; I bade my heart build these poor rhymes: It worked at them, day out, day in, Building a sorrowful loveliness Out of the battles of old times.

You need but lift a pearl-pale hand, And bind up your long hair and sigh; And all men's hearts must burn and beat; And candle-like foam on the dim sand, And stars climbing the dew-dropping sky, Live but to light your passing feet.

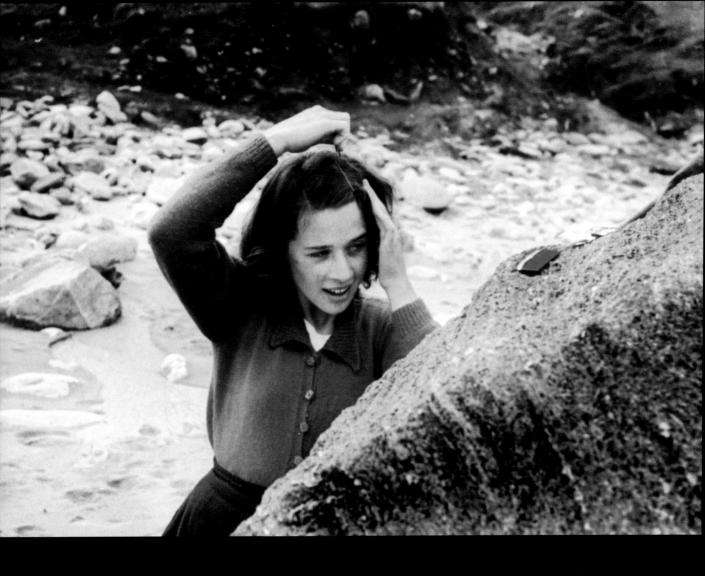

'Mirror, mirror', Achill Island, Co. Mayo (1939).

To his Heart, bidding it have no Fear

Be you still, be you still, trembling heart; Remember the wisdom out of the old days: Him who trembles before the flame and the flood, And the winds that blow through the starry ways, Let the starry winds and the flame and the flood Cover over and hide, for he has no part With the lonely, majestical multitude.

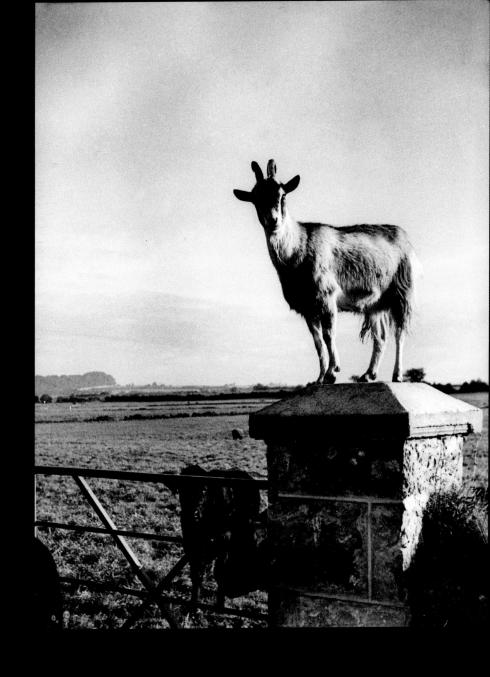

'No fear', Mullaghmore, Co. Sligo (1933).

The Valley of the Black Pig

The dews drop slowly and dreams gather: unknown spears Suddenly hurtle before my dream-awakened eyes, And then the clash of fallen horsemen and the cries Of unknown perishing armies beat about my ears We who still labour by the cromlech on the shore, The grey cairn on the hill, when day sinks drowned in dew, Being weary of the world's empires, bow down to you, Master of the still stars and of the flaming door.

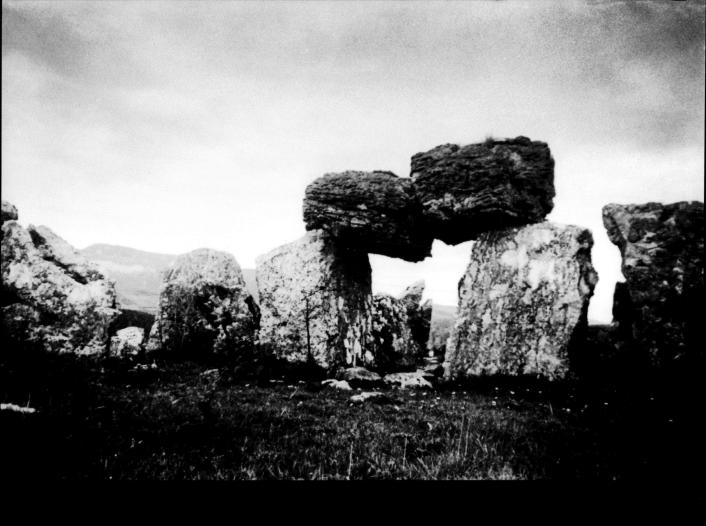

The Giant's Grave, Deerpark, Co. Sligo (1942).

The Lover speaks to the Hearers of his Songs in Coming Days

O women, kneeling by your altar-rails long hence, When songs I wove for my beloved hide the prayer, And smoke from this dead heart drifts through the violet air And covers away the smoke of myrrh and frankincense; Bend down and pray for all that sin I wove in song, Till the Attorney for Lost Souls cry her sweet cry, And call to my beloved and me: 'No longer fly Amid the hovering, piteous, penitential throng.'

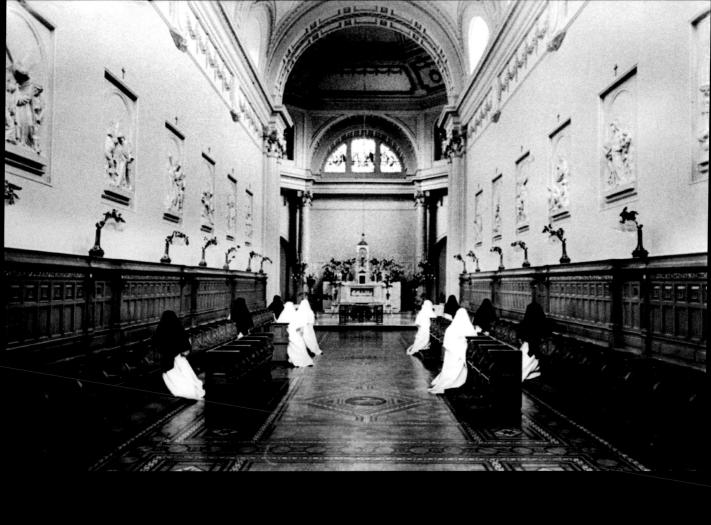

In the Good Shepherd Convent, Limerick (1944).

The Poet pleads with the Elemental Powers

The Powers whose name and shape no living creature knows Have pulled the Immortal Rose;
And though the Seven Lights bowed in their dance and wept,
The Polar Dragon slept,
His heavy rings uncoiled from glimmering deep to deep:
When will he wake from sleep?

Great Powers of falling wave and wind and windy fire, With your harmonious choir Encircle her I love and sing her into peace, That my old care may cease; Unfold your flaming wings and cover out of sight The nets of day and night.

Dim Powers of drowsy thought, let her no longer be Like the pale cup of the sea,
When winds have gathered and sun and moon burned dim Above its cloudy rim;
But let a gentle silence wrought with music flow
Whither her footsteps go.

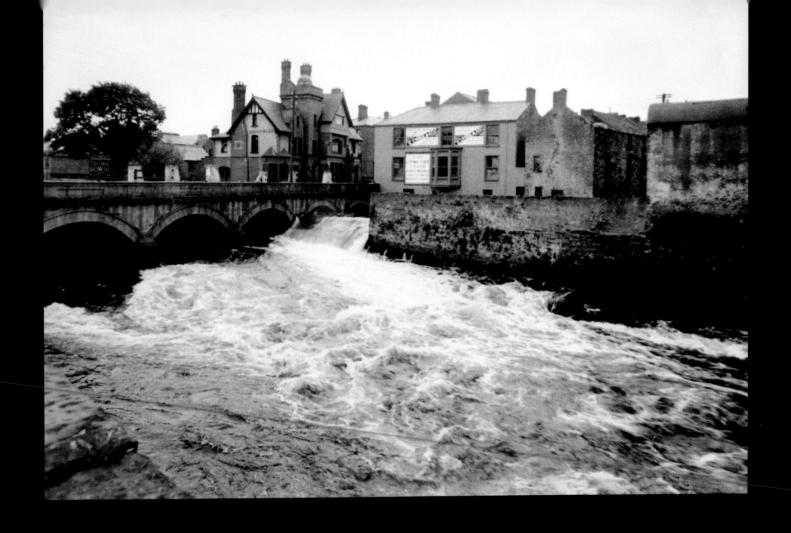

The Garavogue River in spate, Sligo (1942).

He wishes for the Cloths of Heaven

Had I the heavens' embroidered cloths,
Enwrought with golden and silver light,
The blue and the dim and the dark cloths
Of night and light and the half-light,
I would spread the cloths under your feet:
But I, being poor, have only my dreams;
I have spread my dreams under your feet;
Tread softly because you tread on my dreams.

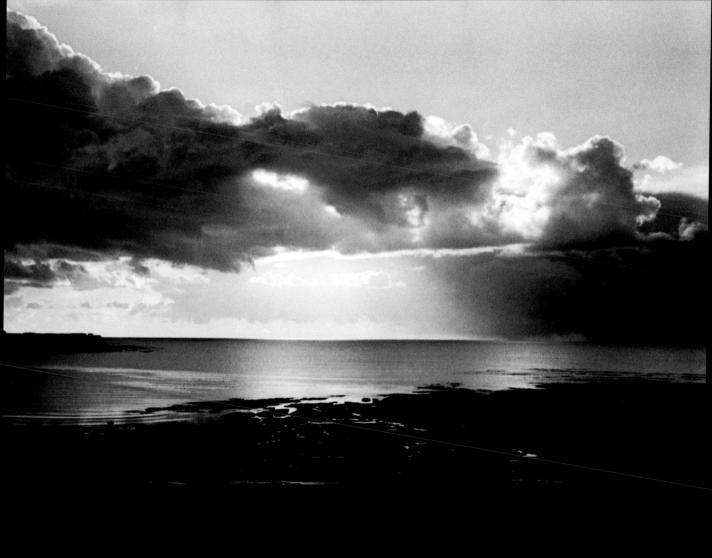

Clouds seen from Ben Bulben, Co. Sligo (1942).

The Fiddler of Dooney

When I play on my fiddle in Dooney, Folk dance like a wave of the sea; My cousin is priest in Kilvarnet, My brother in Mocharabuiee.

I passed my brother and cousin: They read in their books of prayer; I read in my book of songs I bought at the Sligo fair.

When we come at the end of time To Peter sitting in state, He will smile on the three old spirits, But call me first through the gate;

For the good are always the merry, Save by an evil chance, And the merry love the fiddle, And the merry love to dance:

And when the folk there spy me, They will all come up to me, With 'Here is the fiddler of Dooney!' And dance like a wave of the sea.

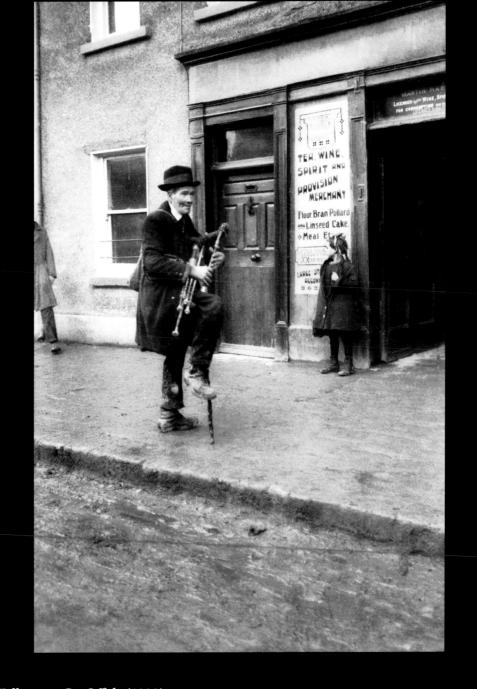

The Old Musician, Tullamore, Co. Offaly (1929).

In the Seven Woods

I have heard the pigeons of the Seven Woods
Make their faint thunder, and the garden bees
Hum in the lime-tree flowers; and put away
The unavailing outcries and the old bitterness
That empty the heart. I have forgot awhile
Tara uprooted, and new commonness
Upon the throne and crying about the streets
And hanging its paper flowers from post to post,
Because it is alone of all things happy.
I am contented, for I know that Quiet
Wanders laughing and eating her wild heart
Among pigeons and bees, while that Great Archer,
Who but awaits His hour to shoot, still hangs
A cloudy quiver over Parc-na-lee.

'Garden bees hum', Emo, Co. Laois (1953).

To be Carved on a Stone at Thoor Ballylee

I, the poet William Yeats, With old mill boards and sea-green slates, And smithy work from the Gort forge, Restored this tower for my wife George; And may these characters remain When all is ruin once again.

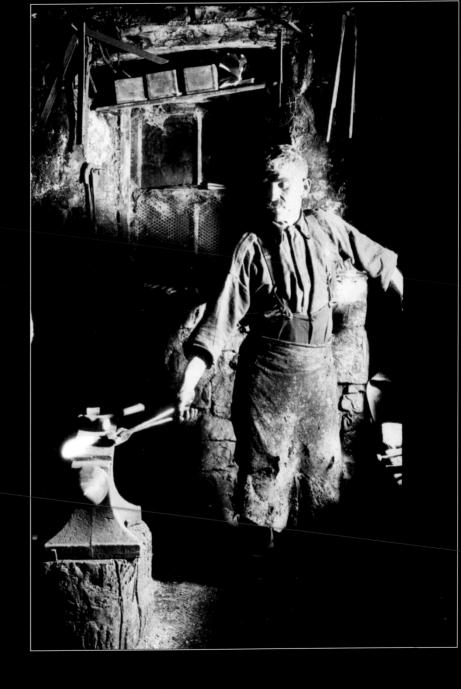

Smithy work, Lisnaskea, Co. Fermanagh (1930).

Red Hanrahan's Song about Ireland

The old brown thorn-trees break in two high over Cummen Strand, Under a bitter black wind that blows from the left hand; Our courage breaks like an old tree in a black wind and dies, But we have hidden in our hearts the flame out of the eyes Of Cathleen, the daughter of Houlihan.

The wind has bundled up the clouds high over Knocknarea, And thrown the thunder on the stones for all that Maeve can say. Angers that are like noisy clouds have set our hearts abeat; But we have all bent low and low and kissed the quiet feet Of Cathleen, the daughter of Houlihan.

The yellow pool has overflowed high up on Clooth-na-Bare, For the wet winds are blowing out of the clinging air; Like heavy flooded waters our bodies and our blood; But purer than a tall candle before the Holy Rood Is Cathleen, the daughter of Houlihan.

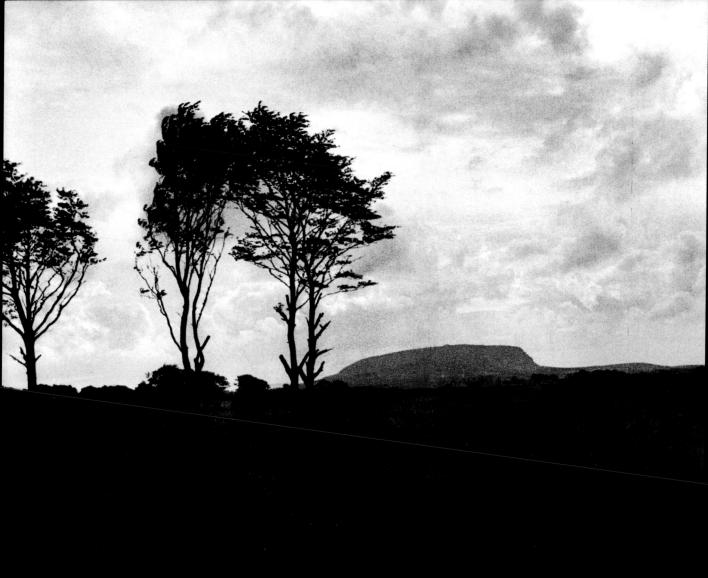

Queen Maeve's Grave, Knocknarea, Co. Sligo (1933).

O Do Not Love Too Long

Sweetheart, do not love too long: I loved long and long, And grew to be out of fashion Like an old song.

All through the years of our youth Neither could have known Their own thought from the other's, We were so much at one.

But O, in a minute she changed – O do not love too long, Or you will grow out of fashion Like an old song.

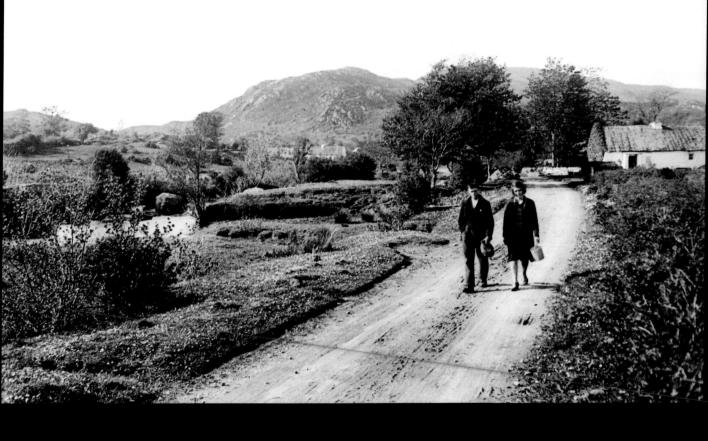

On the road near Tubbercurry, Co. Sligo (1932).

No Second Troy

Why should I blame her that she filled my days
With misery, or that she would of late
Have taught to ignorant men most violent ways,
Or hurled the little streets upon the great,
Had they but courage equal to desire?
What could have made her peaceful with a mind
That nobleness made simple as a fire,
With beauty like a tightened bow, a kind
That is not natural in an age like this,
Being high and solitary and most stern?
Why, what could she have done, being what she is?
Was there another Troy for her to burn?

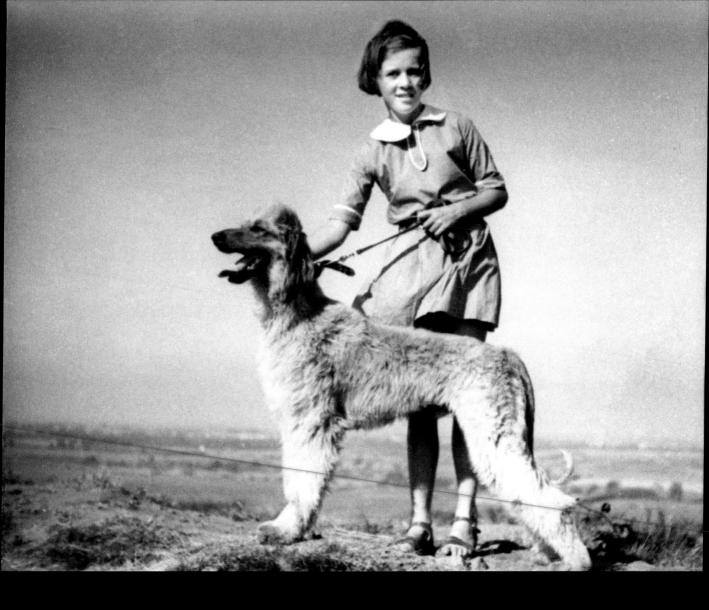

Girl with Afghan Hound, Sussex Downs (1935).

The Rose of Battle

Rose of all Roses, Rose of all the World! The tall thought-woven sails, that flap unfurled Above the tide of hours, trouble the air, And God's bell buoyed to be the water's care; While hushed from fear, or loud with hope, a band With blown, spray-dabbled hair gather at hand. Turn if you may from battles never done, I call, as they go by me one by one, Danger no refuge holds, and war no peace, For him who hears love sing and never cease, Beside her clean-swept hearth, her quiet shade: But gather all for whom no love hath made A woven silence, or but came to cast A song into the air, and singing passed To smile on the pale dawn; and gather you Who have sought more than is in rain or dew, Or in the sun and moon, or on the earth, Or sighs amid the wandering, starry mirth, Or comes in laughter from the sea's sad lips,

And wage God's battles in the long grey ships.
The sad, the lonely, the insatiable,
To these Old Night shall all her mystery tell;
God's bell has claimed them by the little cry
Of their sad hearts, that may not live nor die.

Rose of all Roses, Rose of all the World!
You, too, have come where the dim tides are hurled
Upon the wharves of sorrow, and heard ring
The bell that calls us on; the sweet far thing.
Beauty grown sad with its eternity
Made you of us, and of the dim grey sea.
Our long ships loose thought-woven sails and wait,
For God has bid them share an equal fate;
And when at last, defeated in His wars,
They have gone down under the same white stars,
We shall no longer hear the little cry
Of our sad hearts, that may not live nor die.

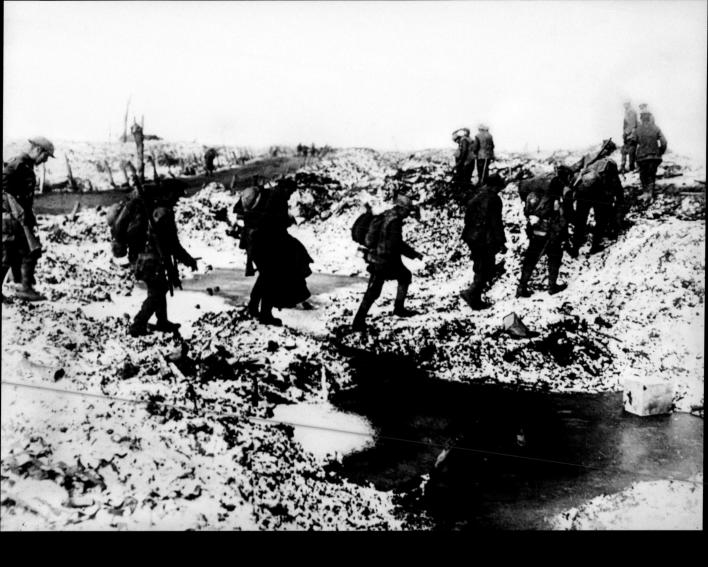

Battlefield, Passchendaele, Flanders (1917).

The Coming of Wisdom with Time

Though leaves are many, the root is one; Through all the lying days of my youth I swayed my leaves and flowers in the sun; Now I may wither into the truth.

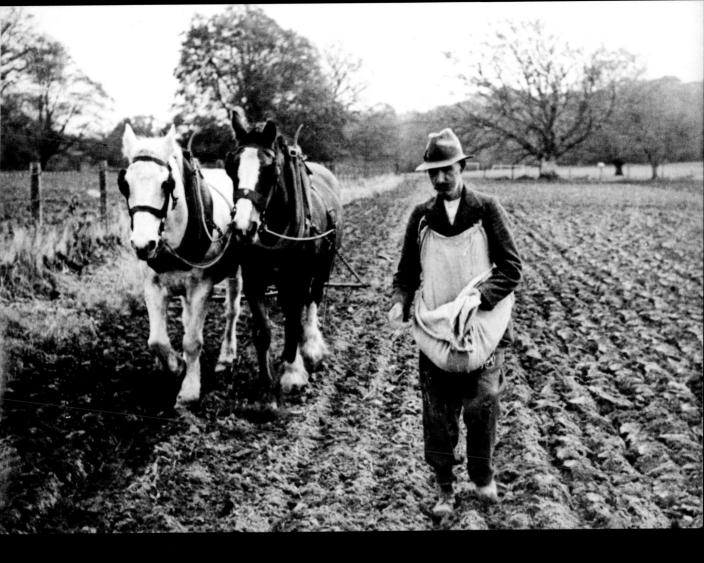

The Sower, Emo, Co. Laois (1931).

These are the Clouds

These are the clouds about the fallen sun,
The majesty that shuts his burning eye:
The weak lay hand on what the strong has done,
Till that be tumbled that was lifted high
And discord follow upon unison,
And all things at one common level lie.
And therefore, friend, if your great race were run
And these things came, so much the more thereby
Have you made greatness your companion,
Although it be for children that you sigh:
These are the clouds about the fallen sun,
The majesty that shuts his burning eye.

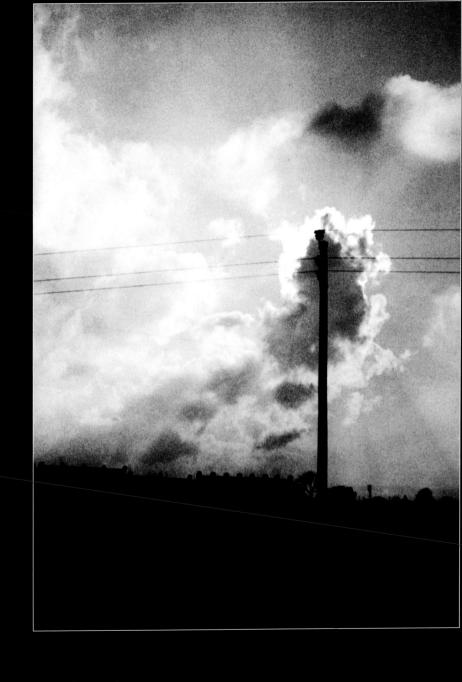

A Friend's Illness

Sickness brought me this
Thought, in that scale of his:
Why should I be dismayed
Though flame had burned the whole
World, as it were a coal,
Now I have seen it weighed
Against a soul?

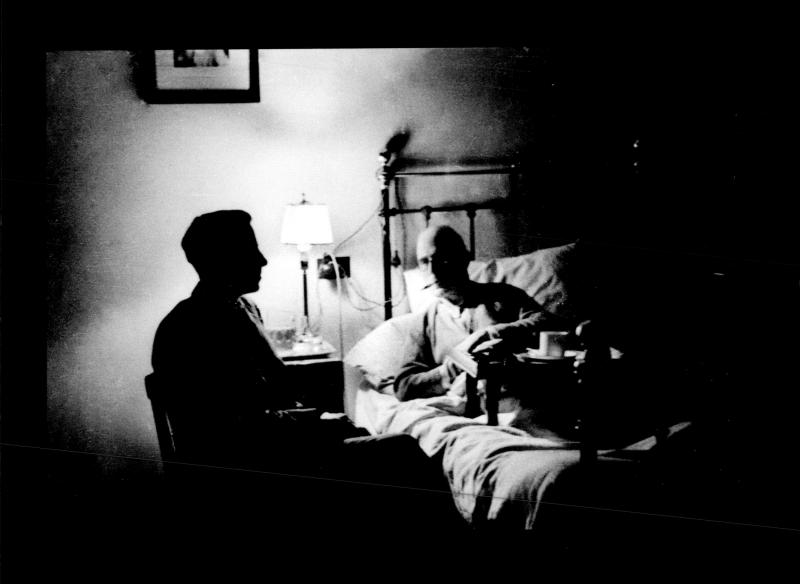

Fr Browne's brother, William, in St Vincent's Hospital, St Stephen's Green, Dublin (1938).

All Things can Tempt me

All things can tempt me from this craft of verse:

One time it was a woman's face, or worse —

The seeming needs of my fool-driven land;

Now nothing but comes readier to the hand

Than this accustomed toil. When I was young,

I had not given a penny for a song

Did not the poet sing it with such airs

That one believed he had a sword upstairs;

Yet would be now, could I but have my wish,

Colder and dumber and deafer than a fish.

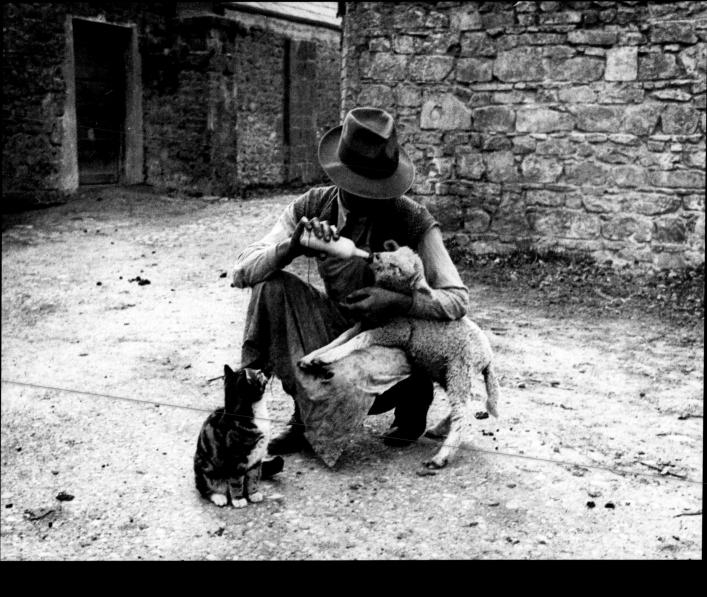

Bottle-feeding the lamb, Cloone, Co. Leitrim (1933).

September 1913

What need you, being come to sense,
But fumble in a greasy till
And add the halfpence to the pence
And prayer to shivering prayer, until
You have dried the marrow from the bone?
For men were born to pray and save:
Romantic Ireland's dead and gone,
It's with O'Leary in the grave.

Yet they were of a different kind,
The names that stilled your childish play,
They have gone about the world like wind,
But little time had they to pray
For whom the hangman's rope was spun,
And what, God help us, could they save?
Romantic Ireland's dead and gone,
It's with O'Leary in the grave.

Was it for this the wild geese spread The grey wing upon every tide; For this that all that blood was shed, For this Edward Fitzgerald died, And Robert Emmet and Wolfe Tone, All that delirium of the brave? Romantic Ireland's dead and gone, It's with O'Leary in the grave.

Yet could we turn the years again, And call those exiles as they were In all their loneliness and pain, You'd cry, 'Some woman's yellow hair Has maddened every mother's son': They weighed so lightly what they gave. But let them be, they're dead and gone, They're with O'Leary in the grave.

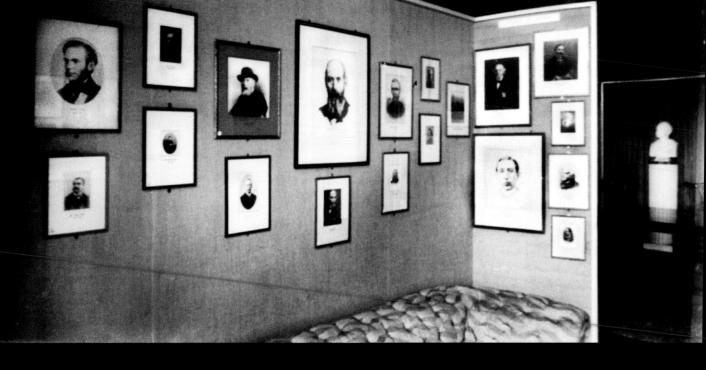

Portraits of John O'Leary and other Fenian leaders, Áras an Uachtaráin, Dublin (1948).

To a Shade

If you have revisited the town, thin Shade, Whether to look upon your monument (I wonder if the builder has been paid) Or happier-thoughted when the day is spent To drink of that salt breath out of the sea When grey gulls flit about instead of men, And the gaunt houses put on majesty: Let these content you and be gone again; For they are at their old tricks yet.

A man

Of your own passionate serving kind who had brought In his full hands what, had they only known, Had given their children's children loftier thought, Sweeter emotion, working in their veins Like gentle blood, has been driven from the place, And insult heaped upon him for his pains, And for his open-handedness, disgrace; Your enemy, an old foul mouth, had set The pack upon him.

Go, unquiet wanderer,
And gather the Glasnevin coverlet
About your head till the dust stops your ear,
The time for you to taste of that salt breath
And listen at the corners has not come;
You had enough of sorrow before death –
Away, away! You are safer in the tomb.

September 29, 1913

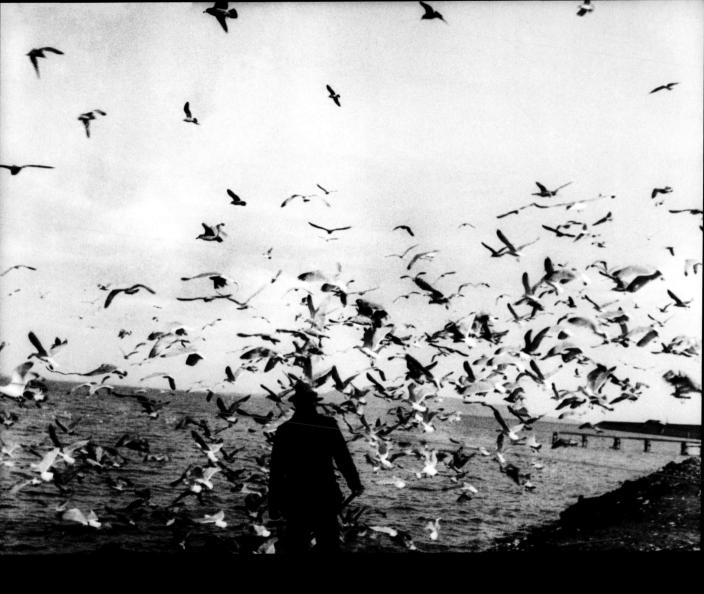

Gulls at Rosses Point, Co. Sligo (1933).

To a Child Dancing in the Wind

Dance there upon the shore; What need have you to care For wind or water's roar? And tumble out your hair That the salt drops have wet; Being young you have not known The fool's triumph, nor yet Love lost as soon as won, Nor the best labourer dead And all the sheaves to bind. What need have you to dread The monstrous crying of wind?

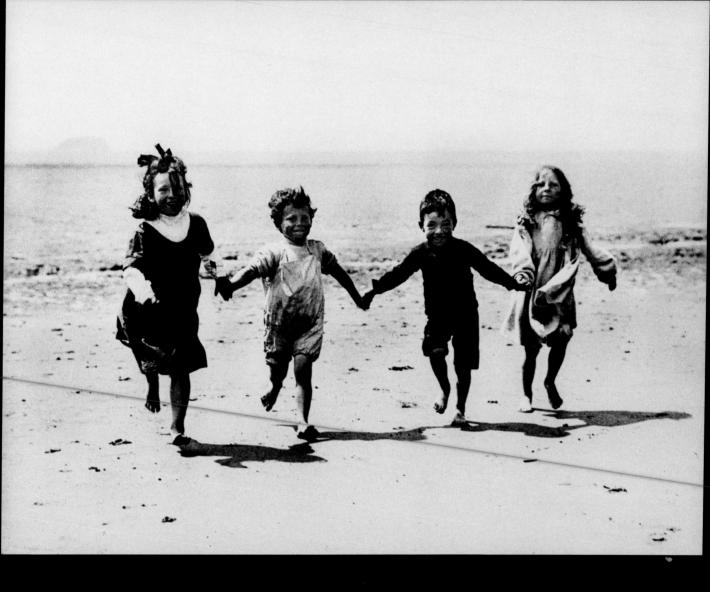

On the beach, Valentia Island, Co. Kerry (1909).

A Coat

I made my song a coat
Covered with embroideries
Out of old mythologies
From heel to throat;
But the fools caught it,
Wore it in the world's eyes
As though they'd wrought it.
Song, let them take it,
For there's more enterprise
In walking naked.

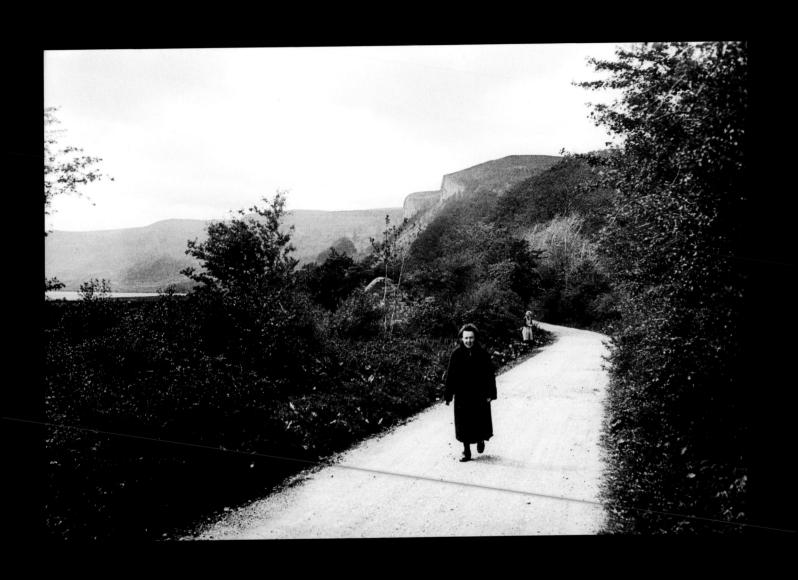

The Long Walk, Glencar, Co. Sligo (1932).

The Wild Swans at Coole

The trees are in their autumn beauty,
The woodland paths are dry,
Under the October twilight the water
Mirrors a still sky;
Upon the brimming water among the stones
Are nine-and-fifty swans.

The nineteenth autumn has come upon me Since I first made my count; I saw, before I had well finished, All suddenly mount And scatter wheeling in great broken rings Upon their clamorous wings.

I have looked upon those brilliant creatures, And now my heart is sore. All's changed since I, hearing at twilight, The first time on this shore, The bell-beat of their wings above my head, Trod with a lighter tread. Unwearied still, lover by lover,
They paddle in the cold
Companionable streams or climb the air;
Their hearts have not grown old;
Passion or conquest, wander where they will,
Attend upon them still.

But now they drift on the still water, Mysterious, beautiful; Among what rushes will they build, By what lake's edge or pool Delight men's eyes when I awake some day To find they have flown away?

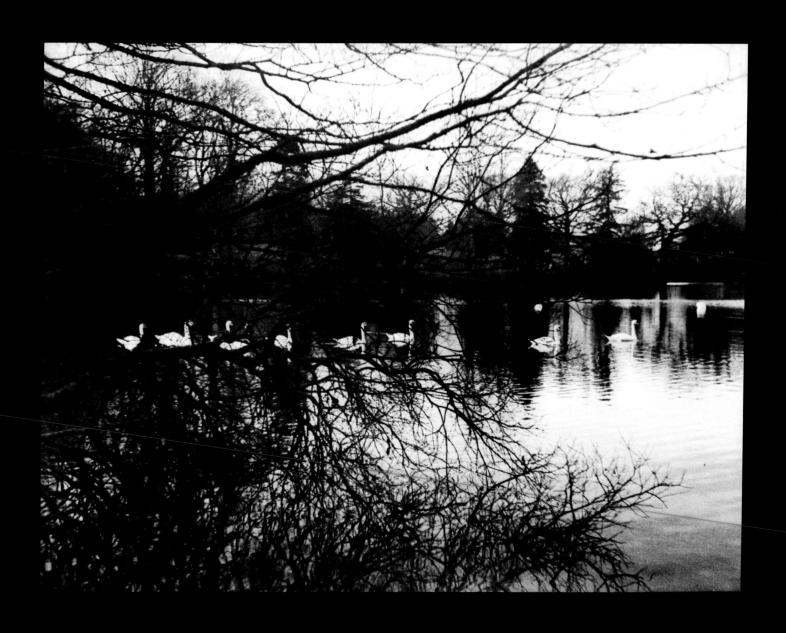

Swans on the lake at Emo, Co. Laois (1937).

An Irish Airman Foresees his Death

I know that I shall meet my fate Somewhere among the clouds above; Those that I fight I do not hate, Those that I guard I do not love; My country is Kiltartan Cross, My countrymen Kiltartan's poor, No likely end could bring them loss Or leave them happier than before. Nor law, nor duty bade me fight, Nor public men, nor cheering crowds, A lonely impulse of delight Drove to this tumult in the clouds; I balanced all, brought all to mind, The years to come seemed waste of breath, A waste of breath the years behind In balance with this life, this death.

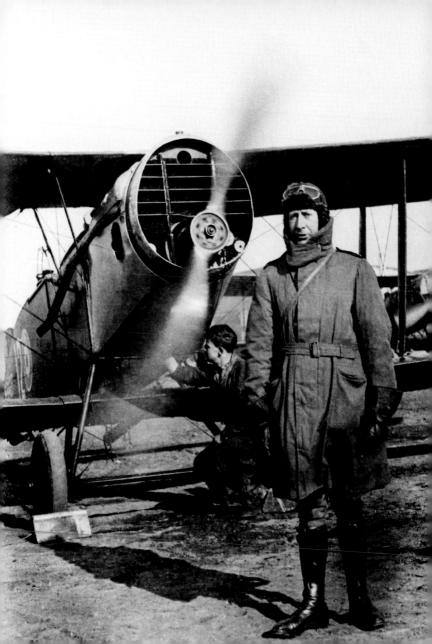

The Fisherman

Although I can see him still, The freckled man who goes To a grey place on a hill In grey Connemara clothes At dawn to cast his flies, It's long since I began To call up to the eyes This wise and simple man. All day I'd looked in the face What I had hoped 'twould be To write for my own race And the reality; The living men that I hate, The dead man that I loved. The craven man in his seat, The insolent unreproved, And no knave brought to book Who has won a drunken cheer, The witty man and his joke Aimed at the commonest ear, The clever man who cries The catch-cries of the clown,

The beating down of the wise And great Art beaten down.

Maybe a twelvemonth since Suddenly I began, In scorn of this audience, Imagining a man, And his sun-freckled face, And grey Connemara cloth, Climbing up to a place Where stone is dark under froth, And the down-turn of his wrist When the flies drop in the stream; A man who does not exist. A man who is but a dream: And cried, 'Before I am old I shall have written him one Poem maybe as cold And passionate as the dawn.'

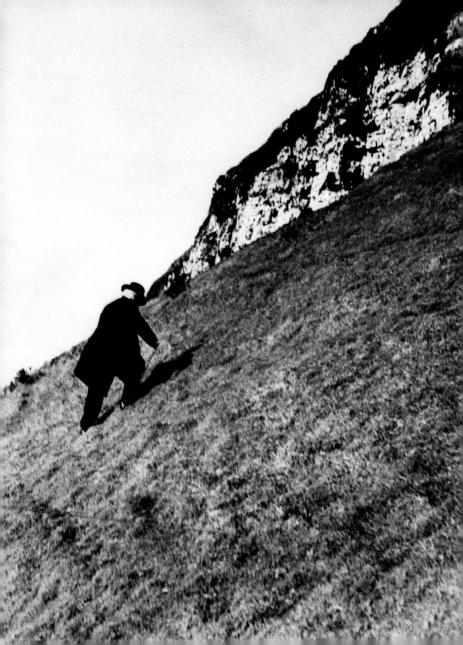

The Cat and the Moon

The cat went here and there And the moon spun round like a top, And the nearest kin of the moon, The creeping cat, looked up. Black Minnaloushe stared at the moon, For, wander and wail as he would. The pure cold light in the sky Troubled his animal blood. Minnaloushe runs in the grass Lifting his delicate feet. Do you dance, Minnaloushe, do you dance? When two close kindred meet, What better than call a dance? Maybe the moon may learn, Tired of that courtly fashion, A new dance turn. Minnaloushe creeps through the grass From moonlit place to place, The sacred moon overhead Has taken a new phase. Does Minnaloushe know that his pupils Will pass from change to change, And that from round to crescent, From crescent to round they range? Minnaloushe creeps through the grass Alone, important and wise, And lifts to the changing moon His changing eyes.

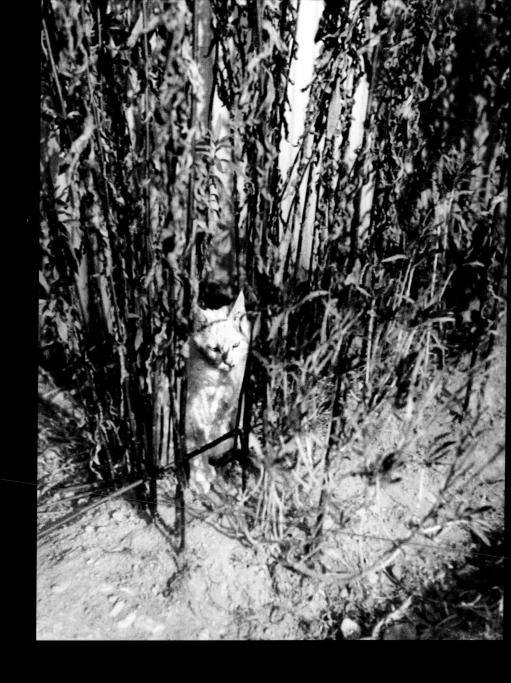

Cat on the prowl, Emo, Co. Laois (1933).

Easter 1916

I have met them at close of day Coming with vivid faces From counter or desk among grey Eighteenth-century houses. I have passed with a nod of the head Or polite meaningless words, Or have lingered awhile and said Polite meaningless words, And thought before I had done Of a mocking tale or a gibe To please a companion Around the fire at the club, Being certain that they and I But lived where motley is worn: All changed, changed utterly: A terrible beauty is born.

That woman's days were spent In ignorant good-will, Her nights in argument Until her voice grew shrill. What voice more sweet than hers When, young and beautiful, She rode to harriers? This man had kept a school And rode our wingèd horse; This other his helper and friend Was coming into his force; He might have won fame in the end,

So sensitive his nature seemed, So daring and sweet his thought. This other man I had dreamed A drunken, vainglorious lout. He had done most bitter wrong To some who are near my heart, Yet I number him in the song; He, too, has resigned his part In the casual comedy; He, too, has been changed in his turn, Transformed utterly: A terrible beauty is born.

Hearts with one purpose alone Through summer and winter seem Enchanted to a stone To trouble the living stream. The horse that comes from the road. The rider, the birds that range From cloud to tumbling cloud, Minute by minute they change; A shadow of cloud on the stream Changes minute by minute; A horse-hoof slides on the brim, And a horse plashes within it; The long-legged moor-hens dive, And hens to moor-cocks call; Minute by minute they live: The stone's in the midst of all.

Too long a sacrifice Can make a stone of the heart. O when may it suffice? That is Heaven's part, our part To murmur name upon name, As a mother names her child When sleep at last has come On limbs that had run wild. What is it but nightfall? No, no, not night but death; Was it needless death after all? For England may keep faith For all that is done and said. We know their dream; enough To know they dreamed and are dead; And what if excess of love Bewildered them till they died? I write it out in a verse -MacDonagh and MacBride And Connolly and Pearse Now and in time to be. Wherever green is worn, Are changed, changed utterly: A terrible beauty is born.

September 25, 1916

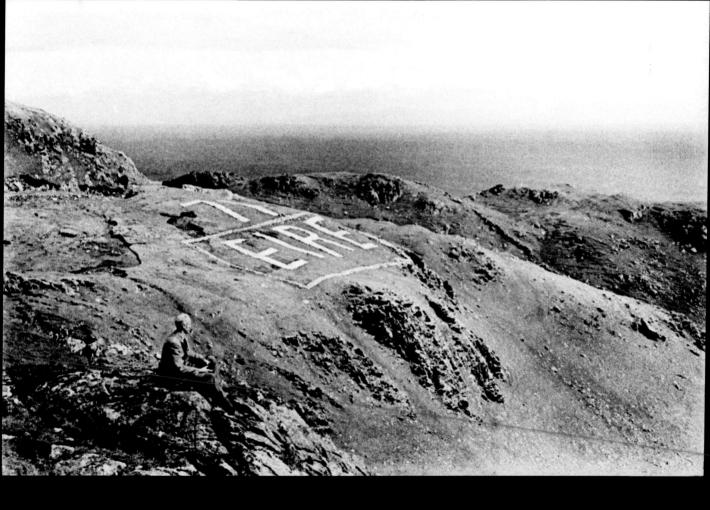

A new country announces itself: with the Yeats' Country in the background, EIRE warns off bombers in 1942.

Sailing to Byzantium

~ I ~

That is no country for old men. The young In one another's arms, birds in the trees,

– Those dying generations – at their song,
The salmon-falls, the mackerel-crowded seas,
Fish, flesh, or fowl, commend all summer long
Whatever is begotten, born, and dies.
Caught in that sensual music all neglect
Monuments of unageing intellect.

\sim II \sim

An aged man is but a paltry thing,
A tattered coat upon a stick, unless
Soul clap its hands and sing, and louder sing
For every tatter in its mortal dress,
Nor is there singing school but studying
Monuments of its own magnificence;
And therefore I have sailed the seas and come
To the holy city of Byzantium.

~ III ~

O sages standing in God's holy fire As in the gold mosaic of a wall, Come from the holy fire, perne in a gyre, And be the singing-masters of my soul. Consume my heart away; sick with desire And fastened to a dying animal It knows not what it is; and gather me Into the artifice of eternity.

\sim IV \sim

Once out of nature I shall never take
My bodily form from any natural thing,
But such a form as Grecian goldsmiths make
Of hammered gold and gold enamelling
To keep a drowsy Emperor awake;
Or set upon a golden bough to sing
To lords and ladies of Byzantium
Of what is past, or passing, or to come.

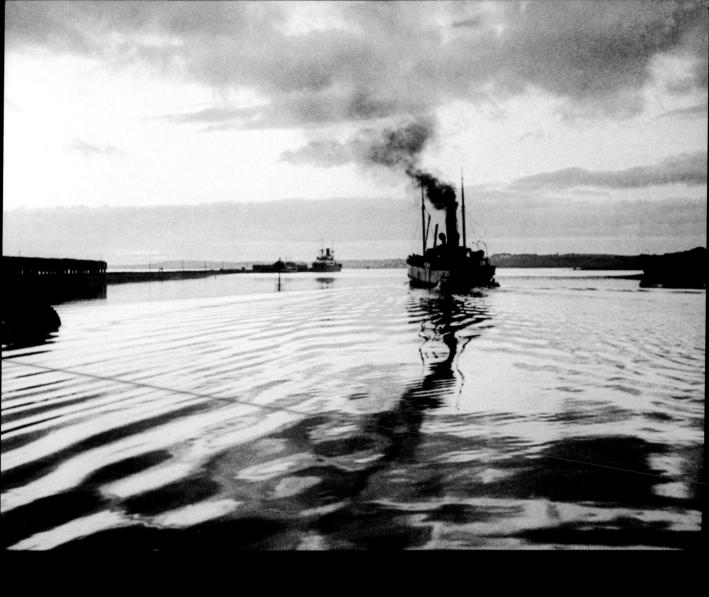

Ship leaving Sligo Port (1933).

The Fool by the Roadside

When all works that have
From cradle run to grave
From grave to cradle run instead;
When thoughts that a fool
Has wound upon a spool
Are but loose thread, are but loose thread;

When cradle and spool are past And I mere shade at last Coagulate of stuff Transparent like the wind, I think that I may find A faithful love, a faithful love.

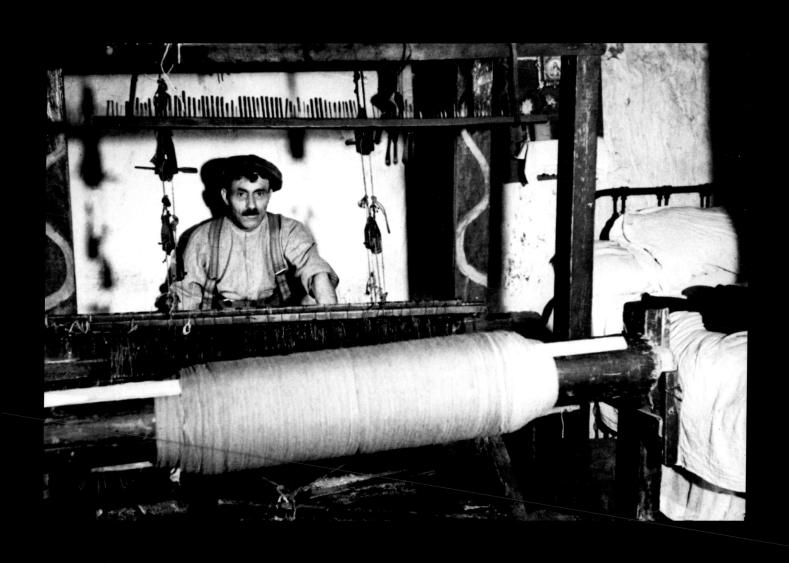

At the loom, Kilmurvey, Aran Islands (1938).

In Memory of Eva Gore-Booth and Con Markiewicz

The light of evening, Lissadell, Great windows open to the south, Two girls in silk kimonos, both Beautiful, one a gazelle. But a raving autumn sears Blossom from the summer's wreath; The older is condemned to death, Pardoned, drags out lonely years Conspiring among the ignorant. I know not what the younger dreams -Some vague Utopia - and she seems, When withered old and skeleton-gaunt, An image of such politics. Many a time I think to seek One or the other out and speak Of that old Georgian mansion, mix Pictures of the mind, recall That table and the talk of youth,

Two girls in silk kimonos, both Beautiful, one a gazelle.

Dear shadows, now you know it all, All the folly of a fight
With a common wrong or right.
The innocent and the beautiful
Have no enemy but time;
Arise and bid me strike a match
And strike another till time catch;
Should the conflagration climb,
Run till all the sages know.
We the great gazebo built,
They convicted us of guilt;
Bid me strike a match and blow.

October 1927

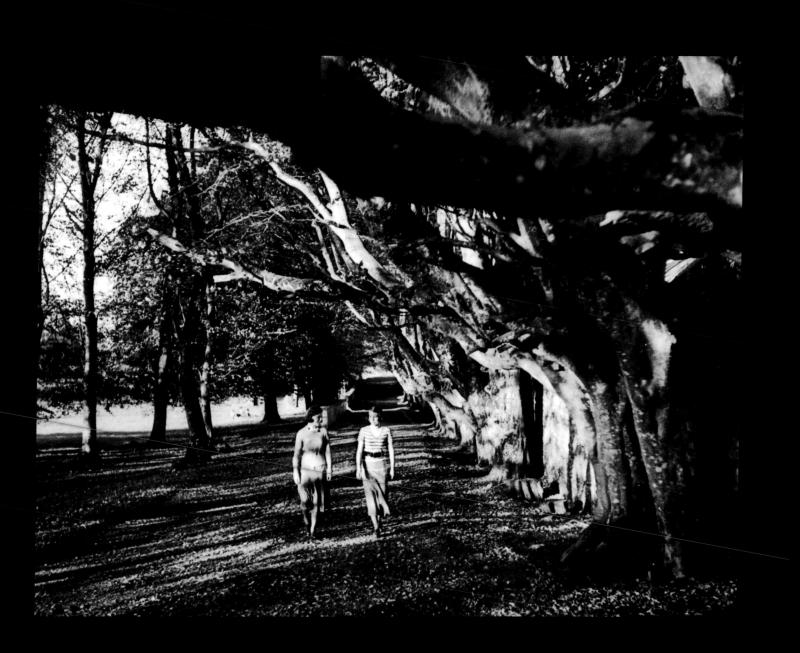

Hope and Prudence French, daughters of Lord de Freyne, in the grounds of their home at Frenchpark, Co. Roscommon (1934).

Symbols

A storm-beaten old watch-tower, A blind hermit rings the hour.

All-destroying sword-blade still Carried by the wandering fool.

Gold-sewn silk on the sword-blade, Beauty and fool together laid.

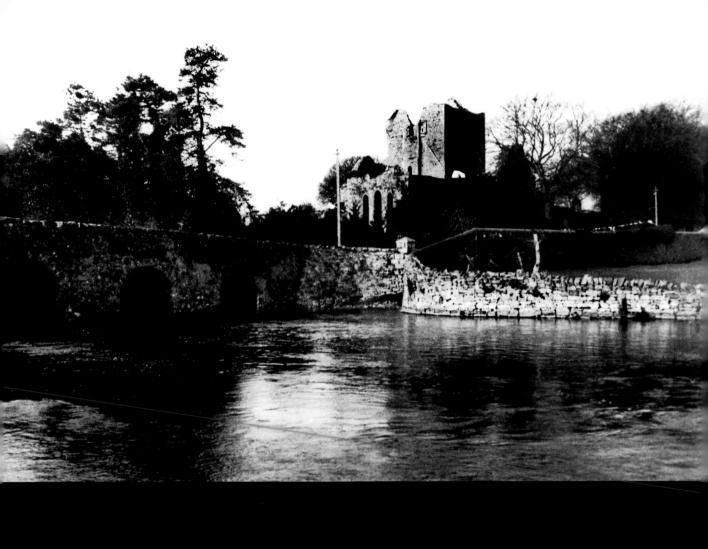

O'Rourke Castle on Lough Gill, near Dromahair, Co. Leitrim (1929).

Spilt Milk

We that have done and thought, That have thought and done, Must ramble, and thin out Like milk spilt on a stone.

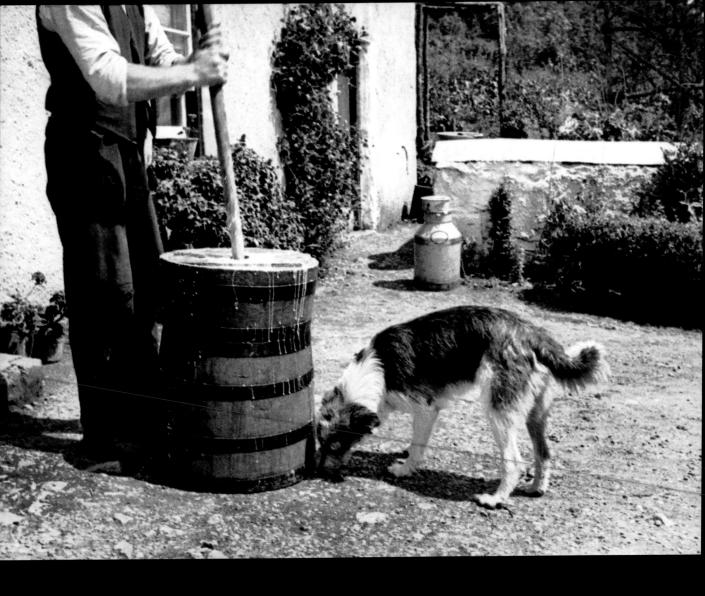

Milk spilt from the churn at Tobernalt, Co. Sligo (1933).

The Choice

The intellect of man is forced to choose Perfection of the life, or of the work, And if it take the second must refuse A heavenly mansion, raging in the dark. When all that story's finished, what's the news? In luck or out the toil has left its mark: That old perplexity an empty purse, Or the day's vanity, the night's remorse.

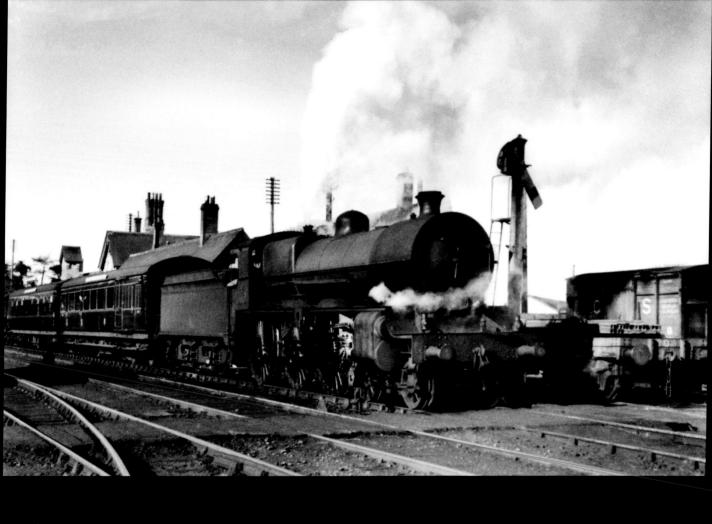

Ireland's newest locomotive, Number 409, heading the Cork-Dublin train at Portarlington, Co Laois (1944).

Gratitude to the Unknown Instructors

What they undertook to do They brought to pass; All things hang like a drop of dew Upon a blade of grass.

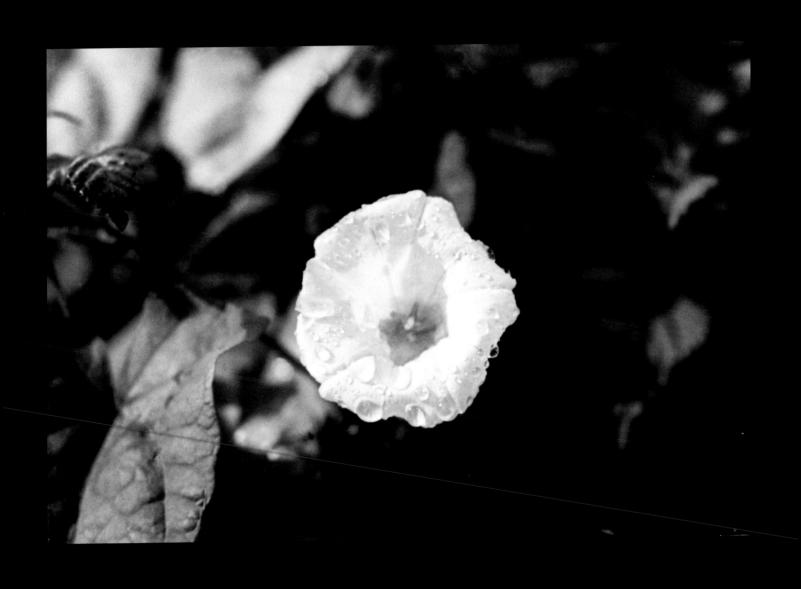

Dewdrop, Portlaw, Co. Waterford (1938).

The Old Stone Cross

A statesman is an easy man,
He tells his lies by rote;
A journalist makes up his lies
And takes you by the throat;
So stay at home and drink your beer
And let the neighbours vote,
Said the man in the golden breastplate
Under the old stone Cross.

Because this age and the next age
Engender in the ditch,
No man can know a happy man
From any passing wretch;
If Folly link with Elegance
No man knows which is which,
Said the man in the golden breastplate
Under the old stone Cross.

But actors lacking music

Do most excite my spleen,

They say it is more human

To shuffle, grunt and groan,

Not knowing what unearthly stuff

Rounds a mighty scene,

Said the man in the golden breastplate

Under the old stone Cross.

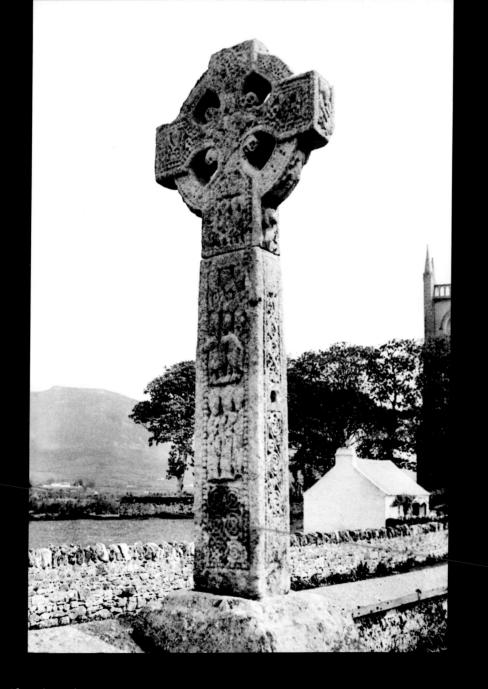

Under Ben Bulben

VI

Under bare Ben Bulben's head In Drumcliff churchyard Yeats is laid. An ancestor was rector there Long years ago, a church stands near, By the road an ancient cross. No marble, no conventional phrase; On limestone quarried near the spot By his command these words are cut:

Cast a cold eye
On life, on death.
Horseman, pass by!

September 4, 1938

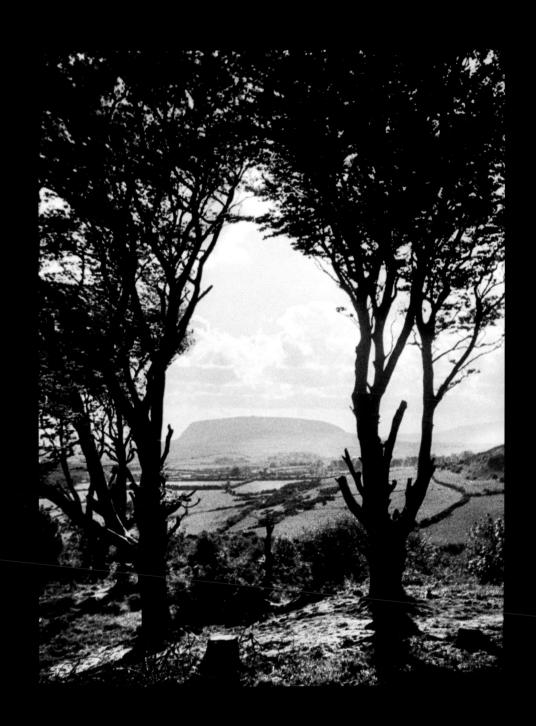

Yeats' Country, Co. Sligo (1933).

Index of first lines

All things can tempt me from this craft of verse90
All things uncomely and broken, all things worn out and old 44
Although I can see him still
Although you hide in the ebb and flow46
A pity beyond all telling34
A statesman is an easy man
A storm-beaten old watch-tower116
Autumn is over the long leaves that love us14
Be you still, be you still, trembling heart60
Dance there upon the shore96
Down by the salley gardens my love and I did meet22
Do you not hear me calling, white deer with no horns?56
Fasten your hair with a golden pin58
Had I the heavens' embroidered cloths
If you have revisited the town, thin Shade94
I have heard the pigeons of the Seven Woods72
I have met them at close of day108
I know that I shall meet my fate102
I made my song a coat98
I rise in the dawn, and I kneel and blow52
I, the poet William Yeats74
I went out to the hazel wood50
I will arise and go now, and go to Innisfree30
O sweet everlasting Voices, be still40
Out-worn heart, in a time out-worn
O women, kneeling by your altar-rails long hence64
Pale brows, still hands and dim hair54
Rose of all Roses, Rose of all the World!
Shy one, shy one
Sickness brought me this

Sweetheart, do not love too long78
That is no country for old men. The young110
The angels are stooping32
The cat went here and there
The dews drop slowly and dreams gather: unknown spears
The host is riding from Knocknarea38
The intellect of man is forced to choose
The island dreams under the dawn
The light of evening, Lissadell112
The old brown thorn-trees break in two high over Cummen Strand 70
The Powers whose name and shape no living creature knows 60
The trees are in their autumn beauty100
There was a man whom Sorrow named his Friend
These are the clouds about the fallen sun
Though leaves are many, the root is one
Time drops in decay42
Under bare Ben Bulben's head120
We that have done and thought118
We who are old, old and gay28
What do you make so fair and bright?'10
What need you, being come to sense92
What they undertook to do122
When all works that have112
When I play on my fiddle in Dooney70
When my arms wrap you round I press26
When you are old and grey and full of sleep36
Where dips the rocky highland18
Why should I blame her that she filled my days80
Your eyes that once were never weary of mine16
You waves though you dance by my feet like children at play